Don't Forget Your Lipstick, Girl

SISTER to SISTER SECRETS
for Gaining
CONFIDENCE, COURAGE, and POWER

DR. MARILOU RYDER
JESSICA THOMPSON

AUTHORS OF
Don't Forget Your Sweater, Girl

DON'T FORGET YOUR LIPSTICK, GIRL

Sister to Sister Secrets for Gaining Confidence, Courage, and Power

©2020 Dr. Marilou Ryder and Jessica Thompson

ISBN 978-0-9904103-6-2 (print)

 978-0-9904103-7-9 (ePub)

Library of Congress Control Number 2020934062

Printed in the United States of America

Delmar Publishing, Huntington Beach, CA 92648

Book design by StoriesToTellBooks.com

Publicity Rights: For information on publicity, author interviews, presentation, or subsidiary rights, contact:

Dr. Marilou Ryder: drmlr@yahoo.com 760-900-0556

Jessica Thompson: rthompson22@comcast.net 978-879-9288

Don't Forget Your Lipstick, Girl

SISTER to SISTER SECRETS
for Gaining
CONFIDENCE, COURAGE, and POWER

CONTENTS

ACKNOWLEDGEMENTS

Don't Forget Your Lipstick, Girl has been an ongoing project over a four-year span. What began as an initial online questionnaire eventually morphed into face-to-face interviews, phone conferences and individual written narratives from women on both US coasts. The advice and stories in this publication would not have been possible without the endless hours of time donated by women who agreed to be interviewed in a variety of ways throughout the life of this project. We extend our appreciation and thanks to the many women who shared their stories, suggestions and advice to other women about gaining confidence, courage, and power both in their personal and work environments. Special thanks to Kelly Davids and Del Ryder for their support in developing the Womantoons.

This book is based on extensive personal interviews of women involved in a variety of business, professional, educational, religious, social and charitable organizations, associations and workplaces as well as research in the areas of sociology, psychology, leadership and gender studies. The field of women who shared their stories cross a wide spectrum which included racial, gender, social, and economic diversity. The process involved interviewing all participants modeled after a qualitative research design. As a result all women included in this project asked that confidentially and anonymity be provided for them to allow for spontaneity and complete honesty. Despite a background as a quantitative researcher, I felt that using identifiers such as 'Interviewee 1' would be too impersonal. Our strategy for using names as identifiers involved asking our participants to choose their own pseudonym, which also provided a great way to help build rapport during the interviews.

Dr. Marilou Ryder

Professor Doctoral Studies

https://www.sistertosistersecrets.com/

INTRODUCTION

WRITE THE BOOK YOU WANT TO READ

by Marilou Ryder

I was commissioned by the Association of California School Administrators to conduct a career workshop for educational leaders on how to prepare for a job interview. Twelve women and four men were in attendance. When I asked, "Who wants to be the first to volunteer for a mock interview?" the four men waved their hands in the air. I was stunned that not a single woman volunteered.

After the men had completed their interviews, I tried to encourage a few women to give it a try, stressing that participation would be a valuable experience. No luck. Finally, I walked over to one woman and whispered, "Come on, you can do this. What's the problem?"

"Everyone will think I'm stupid because I don't know how to answer these questions," she whispered. I tried to persuade her to get some courage. *I'll help you.* With that reassurance, she finally volunteered. Everyone clapped as she walked to the front of the room. Her interview was excellent.

Out of curiosity, I asked the men in the group why they had volunteered for the mock interview. They responded they had nothing to lose and added they were used to taking shots and didn't want to waste an opportunity to practice. Good answer.

Confidence and courage, two words that resonate as I continue to study women, leadership and power. These words have served as my inspiration to write another book for women, a book on women's confidence, courage and empowerment in a male driven society.

For years, men have demonstrated what it takes to excel in their careers, get noticed and win top leadership spots in their organizations. As women we need to ask ourselves what it will take to gain a seat at

the table with our male equals. As a researcher for the past twenty years focusing on women and the gender divide, I believe the answer is quite simple. We need to emulate what men have done all along by developing a strong and deliberate presence in both our work and personal environments. We don't need to compete with men. Rather, we need to match what men have done so well throughout their lives-become fearless competitors, take risks, exude confidence, sit in the front of the room, speak up and take a seat at the table!

The good news for women is that these behaviors and skills can be learned, just like negotiation skills or job interviewing. These skills can be mastered over time through trial and error and experimentation.

The women interviewed for this book continue to demonstrate self-confidence and courage in their lives. They are successful in their jobs, personal lives and manage to conquer fears that could potentially limit their sphere of influence on the world. They are not invincible, but rather lifelong learners and generous with their time and spirit. They share examples and experiences from their lives hoping to inspire other women to explore their own personal power agendas.

Hopefully, each interview and POWER TIP in this book will have something that motivates you to embrace a new challenge or goal that you've been thinking about with confidence and courage.

In writing this book, I thought about my own life as one of constant goal setting coupled with passionate service to others. While focused on setting one goal after another to improve and become a better person, I learned some valuable lessons along the way about being a female.

As a kid I was left out of sports, as a teen I was told I was too fat, and as a high school student I was informed that I needed a college education to fall back on in case I couldn't find a husband. As a career woman, I discovered competing for jobs traditionally held by men was an enormous challenge. As a woman, finally holding a position of power I was stunned I would be paid less than a man. While all

these obstacles served as learning experiences, I never lost my desire to help other women overcome these same obstacles and barriers. My quest to help women, through mentoring, speaking and writing motivates my spirit. Not only am I inspired to support women to succeed in a very complicated world, but I have learned through experience to better understand my life's journey. My passion to help women navigate the maze of discrimination and perceived internal and external barriers in their personal and professional lives is what wakes me up in the morning. And together we will make a difference!

LIVE IN THE MOMENT

by Jessica Thompson

Live in the moment! That's my motto now that I am 62 and living in Florida with my husband. Since writing Don't Forget Your Sweater, Girl, I'm confident I made the right choice to enjoy my final chapters under the palm trees with my toes in the Gulf. When deciding to retire in Florida I was approached by a prominent author, my sister, to co-author a book on women and aging. What perfect timing for another career! I knew I could be of value to her project. I too wanted to make a difference in the lives of women. When first approached, I wasn't handling the transition into my 60s gracefully and had difficulty accepting the reality of turning old. Working with so many women on this book through formal interviews was enlightening. We began to call these women our Ambassadors of Aging.

Their message helped me become more comfortable with who I was becoming. I learned how to pause and enjoy this part of my life. I loved every minute of pulling this project together and learned so much. Working with a partner on a project was uplifting and even better to work with my sister. We balanced one another and connected electronically on a stage that flowed so cohesively. My sister presented me with a new career opportunity and once again I took the bait! I'm forever grateful for this chance of a lifetime which enabled me to believe that I have the confidence and courage to do anything I put my mind to. And that I can do it well.

This next project is challenging but so close to my heart. Having two amazing daughters in the business world on their own, paving their way through the next decade has given me the confidence to collaborate on this book. I want these two women to see a difference from when I bulldozed my way up the career ladder in the 70s and 80s.

A limited amount of change has occurred but not enough. Why is it today that I still hear women discuss similar issues that existed 50

years ago? I'm the only woman; He makes more money in the same position; He transferred from another company with no experience but was promoted before me; My manager is a man who wants to promote a man before me with less loyalty and experience; I am the only woman among 30 men in a scheduled meeting to solve problems of diversity in our company; There are no networking connections for women in our company so I am going to start one. The list is significant.

Today's women can position themselves to be recognized and heard in a professional and assertive manner. The women of today are stronger, smarter and braver than I ever was in the 70s and 80s. We have a much stronger voice with so much successful history behind us. Many women paved the way for us, and we must do the same for the future women of tomorrow. Let's grab each sister's hand next to us, move forward, lead from example and gain from the knowledge we acquire today. A few Sister to Sister Secrets might help us all reach that pinnacle sooner than we think. And yes, Don't Forget Your Lipstick, Girl!!!

Bethany set a goal to spend less and save more.
She quickly learned that the 20% Botox special
wasn't one of them. "Oh well, not too bad if
I part my hair on the right side."

WHY YOU SHOULD READ THIS BOOK

BREAKING NEWS: The jury has spoken; the evidence is clear. Women have been told that if we just play by the rules, work hard and gain enough training and education that we would be recognized and rewarded. According to an article scripted in the Atlantic monthly we've made undeniable progress. "Women now earn more college and graduate degrees than men do. We make up half the workforce, and we are closing the gap in middle management. Companies employing women in large numbers outperform their competitors on every measure of profitability. Our competence has never been more obvious. Those who closely follow society's shifting values see the world moving in a female direction."[1]

✑

We have worked hard and done the required work to gain equality. Yet the sad truth is that women are not equal with their male counterparts both domestically and globally. Consider the following:

+ One in five women on U.S. college campuses have experienced sexual assault.
+ Approximately 1 in 3 women have experienced physical or sexual violence at some point in their lifetime.
+ Women earn just 83 cents for every dollar men make in 2020.
+ Women comprise only 5% of Fortune 500 CEOs.
+ Over 62 million girls are denied an education in the world.
+ Women represent only 23 percent of members of Congress.
+ The average college graduate who becomes a mother will sacrifice a million dollars over her lifetime.
+ Women are more likely to be unemployed than men.
+ Over half of the women working in STEM fields will eventually leave because of hostile work environments.

This list of inequities and challenges for women extends ad infinitum. When Googling 'women and inequality' the number of citations is endless. The facts speak for themselves and now it's time to become part of the solution. And that will take some work!

We have broken through many barriers in our attempt to gain a seat at the table. But there's something more basic that has prevented women from breaking through the glass ceiling and gaining personal power in her life. And that something is called a lack of confidence.

Kae has a doctorate degree in organizational leadership but is afraid she doesn't have the skills to apply for a director job in her company. Alissa won't raise her hand in a meeting because she feels everyone will think she's stupid. Cara is afraid to ask for a raise after five years in the company but doesn't want to upset the apple cart. Rita an abused woman is afraid to leave her husband. And Alma, a former executive director and now a stay at home mother feels guilty accepting a part-time position offered from her company.

Self confidence is subtle. Some people think you either have it or you don't. That's not always true. Every woman we talked with shared examples when they felt a lack of confidence in their lives. Most women agreed; the byproduct of a lack of self-confidence was damaging personally and professionally. Everyone recognized it, wanted to talk about it, and were eager to share how they tried to conquer its confusing and crippling effects. Some women at the top of their careers reported that gaining confidence was like a work in progress. "I'm at the top of my field, I'm 58 years old, and still worry that I'm not as good as I should be. I still doubt myself and am envious of the men who don't seem to suffer from self-doubt and lack of courage. Or if they do feel self-doubt, they don't let it get in the way of being successful or getting their needs met. These men don't seem to have the need to be liked by everyone."

The need to be liked, to please everyone, and serve others and make peace are part of our DNA and it's been drilled into us since birth. So, it begs the question we must all answer; what will it take for women to

release themselves from their self-doubt and lack of courage that continue to hold them back from the lives they truly deserve?

And that is why we wrote this book. This book delves into stories from women who demonstrate *confidence* in their lives. They recognize confidence's insidious manner and know it can rear its ugly head at any moment. And when it does surface, they have learned to self-reflect and summon internal courage to become empowered to make a difference for themselves and their sisters.

Read this book to...

...develop a strategy to become more confident and empowered. Take note of your current work and personal situations and assess your strengths and weaknesses. Then use some of the tools presented throughout this book to craft out a short/long-term personal action plan. While one person can't change the world overnight, every small step taken toward making the world a better place for women and young girls counts.

‿

Read this book to...

...discover tools to help you take a seat at the table with your male counterpart. The answer is quite simple. Do what men have done all along. Develop a strong presence in the workplace, at home and in your community. You don't need to compete with men but rather emulate what men have done so well throughout the world; *that is be a fearless competitor, take risks, exude confidence, sit in the front of the room and speak up to be heard!*

‿

Read this book to...

...learn how to build your *Executive Presence*. In the world of work, men have demonstrated what it takes to get noticed to get what they want, and many times it's been at the expense of women. People in the

field of career development refer to this skill as "Executive Presence," the ability to engage, align and inspire people to act. Executive Presence is part having charisma, part communication and part having a well-defined personal and professional manner and empowerment. It's something that can be learned like negotiation skills or job interviewing and something that can be mastered over time through trial and error and experimentation.

～

Read this book to...

...take a quick peek into the lives of women who exude confidence, courage and power and learn from their stories. Their advice for gaining power and influence through their keen awareness of executive presence strategies is powerful. Sharen, a senior auditor for a large accounting firm discussed the changes she experienced to both her personal and professional life through her awareness of these strategies. "Some actions that we can do as women to be heard and respected are so simple, like being able to say 'No' to things we don't need or want to do. I feel liberated when I get the courage to say something like, *no I don't want to host the office party*. Other skills, like learning to listen are a bit more complicated, but with practice we can make a significant difference in how we are viewed in the world as mothers, sisters, friends, wives and leaders."

～

Read this book to...

...become inspired by other women which will hopefully inspire you to learn new skills to increase your confidence and courage. By doing so you will find that you become and feel more powerful in your life. You will gain the confidence and tools to lean in, be heard, change policies, help other women and take an equal seat at the table with men.

~

Read this book to...

...acknowledge what you already do well. Then take note of areas to focus on for your continuous self-improvement. Find a yellow marker and highlight areas to work on today. Get some sticky notes and bookmark those ideas that resonate with you. Let's get to work and become empowered. *There's no time to waste!*

GOT SUPERPOWERS?

FIND YOUR EMPOWERMENT QUOTIENT

An empowered woman is someone who knows her strengths and isn't afraid to embrace them. To be empowered means to be in control of your life, aware of your capabilities, and ready to take on your biggest dreams. As you read each question, write the number in the blank that best reflects how you are thinking and feeling today, not how you felt last week or how you speculate things may be next week. Your answers today will become part of your guide throughout this book.

Rarely	Not Very Often	Occasionally	Frequently	Most of the Time
1	2	3	4	5
	When someone gives you a compliment you don't downplay the compliment, but kindly accept and say, "Thank you."			
	You continue to seek out and learn new things.			
	You limit your time hanging around negative people.			
	You rarely feel jealous of other women.			
	You avoid negative self-talk at all costs.			
	When you need to let someone know you are unhappy with a situation you speak to them calmly and assertively.			
	You surround yourself with people you admire and respect.			

	You are not susceptible to guilt trips.
	You have two to three mentors in your personal and professional life.
	You look people in the eye when speaking with them.
	You control your tears and emotions in the workplace.
	If you have a problem with your children or significant other, you keep it to yourself and avoid sharing it with people at work or asking them for advice.
	Before speaking to a large group, you organize your thoughts and ideas in advance.
	When someone criticizes you, you listen, assess and then move on.
	You feel liberated when taking a day off from work.
	You are known as a positive person with a friendly smile.
	You are rarely late for meetings or important events.
	You avoid office gossip at all costs.
	You have eliminated the phrase "I'm sorry" from most of your conversations.
	When you get into a good debate with another colleague and it doesn't go your way, you take it in stride as part of having a good dialog.
	You care how you look or dress at work or out in public.

	You look forward to new situations at work and in your personal life.
	You seek out powerful women in your life.
	You don't spend a lot of time trying to be perfect.
	Your personal and work life are in synch with one another.
	You ask for help when needed.
	You can make a big decision without procrastinating.
	You are aware that failing at tasks can build self-confidence.
	You have a 'big picture' idea of where you want to be in the future.
	You set yourself up to be a winner by doing your 'homework' and planning.
	You say "Yes" when presented with a professional growth opportunity.
	You say "No" when asked to take on too much at work or in your personal life.
	You participate in a routine exercise program.
	You do something to challenge yourself every single day.
	You try to set realistic goals for yourself rather than setting the bar too high.
	ADD FOR TOTAL SCORE

SCORING

The maximum score you can have is 175, which is unlikely. One of the greatest secrets powerful women share is that there are times they don't feel confident or powerful. In fact, they often feel that confidence and courage totally elude them. After reading and incorporating some of the advice and stories from the women in this book, we hope your overall level of empowerment will be challenged and encouraged. We support you through your journey and truly wish you success while becoming a woman of power both in your work and lifestyle environment.

170-175 | WONDER WOMAN

You are a confident, courageous and empowered woman and have learned how to maximize and grow your inner strength for a successful life. People at work and in your personal environment view you as a woman of influence and power. You are well on your way to becoming a very powerful, influential and successful woman.

130-169 | ON THE MOVE

You have a great deal of confidence and courage and can gain more with just a bit of fine tuning. You continue to work on specific strategies to gain greater confidence and courage to become the woman you are capable of. You have the key ingredients to be a powerful and influential woman, but just need to stretch yourself a bit.

0-129 | IN TRAINING

Your confidence and courage is shaky and you know it's time to step back and do some probing of what to do to improve your life. Many of your thoughts and actions get in your way. Reread some of the tips shared in this book and chart out some targeted strategies to work on in the next few months. Learn to trust yourself and follow your passions, not others. Good luck, we care!

Don't Forget Your Lipstick, Girl

Do you wear something special that gives you courage and power? Is there a favorite perfume, necklace or pair of heels that makes you feel confident? Many women share they often use symbolic artifacts to help gain self-confidence and courage. Sandra, a corporate executive, acknowledged that she always wears Oscar de La Renta. "I started wearing Oscar when I was thirty years old, new in my career. People complimented me on the fragrance, and I still wear it today. I believe this perfume gives me a bold sense of confidence and courage. Silly, huh? Maybe, but it works for me."

Power is elusive and no one person or magic wand can bestow power on you. Personal power comes from within and only you can generate your own power. Sometimes a certain piece of clothing or make up style can give a woman that "kick ass" feeling. Finley, a successful business owner, shared that wearing red lipstick has become her unique signature. "Let's face it, the world is getting very diverse and it's more difficult to make a personal statement. I want to look different and stand out so red lipstick has become my trade mark. With my red lipstick I feel like I can take on anything that comes my way. I never go out in public without it."

POWER TIP

Wear what makes you happy, resilient, confident, courageous, unabashed and powerful!

Red lipstick has quite a story when it comes to powerful women. History reveals that Cleopatra made her own shade of red lipstick by crushing ants and beetles. And despite the belief that wearing red lipstick would challenge God, Queen Elizabeth

wore dark red lips against her white powdered complexion. Then in the late 1800s red lipstick took a turn for the worse when Queen Victoria proclaimed any use of cosmetics, particularly red lipstick, was to be discouraged since the majority of women who wore red lipstick were prostitutes. And in 1880 Sarah Bernhardt, an actress and well-known feminist was responsible for bringing red lipstick back in style. She was often seen applying red lipstick in public which challenged social etiquette for women. Sarah's behavior drew widespread attention, making red lipstick fashionable once again. Finally, in 1910 Elizabeth Arden, a rarified female business owner broke new ground when her Fifth Avenue store showcased a new shade of lipstick, *Red Door Red*. Historians report that Elizabeth gave the Suffragettes free lipstick tubes as they marched in the streets in front of her store triggering red lipstick as a symbol of hope, power and strength for women.[2]

While red lipstick boasts a compelling story as a symbol of strength and power, some women report that they don't wear lipstick. Rather, a signature perfume, spiked heels, designer jeans, red nail polish, Louis Vuitton bag, favorite watch, or Fitbit often serve as confident boosters. The psychology behind these objects of affection for building inner confidence is deep and women are keenly aware of their intrinsic influence on their personal power. Whatever the motivation or item, the message is clear - wear what makes you happy, resilient, confident, courageous, unabashed and powerful. And don't leave home without it!!!

Just-a Girl

Have you ever caught yourself saying, "I'm just a mother, I'm just a director, I'm just a whatever?" If so, stop! You are special whatever your role is, so own it. Be proud of who you are and never undermine your own talents. Walk into any room knowing you are an asset. Know who you are and what your true value is.

Negative self-talk, from "I'm such a jerk for messing up that presentation" to "I'm not good at public speaking" is paralyzing and destructive and should be avoided at all costs. When you fill your mind with statements such as, "I'm too young, too old, I don't have the talent, I can't learn tech, I can't, I can't…" you lose. Your inner voice takes you down with each variation.

POWER TIP

Be bold, own who you are and keep growing.

Deleting negative self-talk should be at the top of your list! Anita, a senior government worker says she cringes when she hears one of her female employees say, *I'm just an aide, I'm just a secretary.* "I am a fierce women's advocate, so I try to coach women to be proud of who and what they are. It seems to make a small difference."

Emily, a former director and current stay at home mom, learned her lesson the hard way. "I was sick and tired when people would ask me what I did for a living. While attending my daughter's school assembly a man overheard my conversation with the woman sitting next to me when she casually asked if I worked. I responded with a disgruntled smirk on my face, *"I'm just a stay at home mom."* The man interjected himself into our conversation

sharing that his wife was also a stay at home mother and added how important he thought her job was.

His words reverberated through my head. Before taking a leave from work to raise my kids I was a very accomplished director of a tech company. I was embarrassed when people would ask me what I did for a career. Inside I knew my "just a mom" responses drained my confidence. While I was financially able to stay home, I felt the world was passing me by. I loved my kids but had to admit that I didn't place a high value on being a mother in today's high achieving society. After this man's piercing comment, I did some serious thinking about my self-awareness. I also read about other mothers who felt the same way. As a result, I created a small consulting business to keep my resume alive and started doing some part-time work from home."

Sometimes, *just-a* thinking can be both paralyzing and motivating. So, if you're *just-a* supervisor and your inner voice starts nagging, do what it takes to move your package along to the next level.

Out of Office

Ask yourself three questions. Do you remain at work longer than your coworkers, even when your work is completed? Are you afraid to take a vacation thinking something will happen when you're not there? Do you answer email messages throughout the weekend and late into the night? If the answer is 'yes' read on.

Everyone has responsibilities, especially when serving in key career roles. But overworking can be physically and mentally exhausting and counterproductive. Take time to truly be 'off work' for self-reflection and rejuvenation. Try to work smarter, not harder.

This thinking is difficult for women who believe they must be better, smarter, and more accomplished than their male colleagues in

order to get ahead or receive a job promotion. Really, do you need to work 18-hour days or answer endless emails on Saturday night to be perceived as qualified? When was the last time your male boss was the last one to leave the office? Working 12-hour days may be required sometimes but it should not be your norm.

Danielle, a government official, was the first woman promoted to her position in the county. "I was working 18-hour days just to keep up with the work-load." She shared that she couldn't keep the pace up and eventually got sick, losing both time and money. "Those were tough times. Now I work a normal 8-hour day and call it quits. I realized how important it was for me to have my down time. I am not going to work myself to death."

POWER TIP

Don't make sleep deprivation your drug of choice.

Angie thought she needed to prove herself after being hired as the company's first women senior accountant. "I was scared to death that I didn't have the skills compared to the former guy who held this position. After two to three months, I thought, this is crazy. I can't keep this up. I'm doing a great job and I don't need to keep proving myself."

Eye of the Tiger

Here's a thought. Sit up straight, look people in the eye and be purposeful with hand gestures whenever talking. Most men have no trouble looking people in the eye when delivering a message. Women on the other hand, often feel that looking someone in the eye for more than five seconds is confrontational and even uncomfortable. Looking someone in the eye while speaking can send a message of confidence and power. Try it. You'll like the results.

POWER TIP

Look someone in the eye when talking. It signals confidence!

Alex, an aspiring financial consultant, noticed that most of her male colleagues have excellent eye contact. "One day I decided to look my supervisor in the eye while talking without looking away too quickly. Guess what? It was easy and an immediate sense of power came over me that I've never experienced before."

Good eye contact is an important communication gesture that should be mastered early on. If your eyes constantly hop around and rarely connect with the person you're talking with, your remarks could be misinterpreted. A subtle message is sent that your concerns, opinions, or statements are not important. A woman is more likely to be taken seriously when using direct eye contact.

Never Let 'Em See You Cry

We are emotional. That's what makes us special. We can build trust quickly with others and establish positive teams. What we may not know, however is that sometimes our emotions can be perceived as weak, especially in the workplace. Crying at work is one of those emotions and does not translate to a sign of power.

January, a manager of a glass company confessed that she lost it one day because she was overtired, and work was piling up. "My boss came into my office and commented, *You look tired, is there anything I can do to help?* I fell into his sympathetic trap and started bawling my eyes out. While he was very comforting and took some of the immediate pressure off my shoulders, in retrospect, I think he lost confidence in me. Our relationship was never the same after that and I was passed over for many promotions before moving on to another company."

POWER TIP

To prevent your-self from crying in public, roll your eyes up into the back of your head.

Excerpts from Ryder & Briles. *The SeXX Factor: Breaking the Unwritten Codes that Sabotage Personal and Professional Lives (New Horizon Press, 2003).*

Problem Child

My husband is having an affair. My kid's in jail. I've got another UTI. Sharing too much personal information at work to co-workers and bosses can be counterproductive. Personal issues such as family prob-

lems, life-changing situations, emotional difficulties, illness, and even one's sexual orientation can impact your job and ultimately your ability to advance your career. Most experts advise women to keep their private lives separate from their work life, as inevitably one may begin to run into the other. It is critical to learn how to keep personal issues from negatively affecting your job and career. [3]

It is well documented that women "tell their hearts out" to everyone at work. Stop it. No one wants to hear about all your problems. Also, if you need to take a day off from work for a family emergency spare your boss the details. Just ask for the day off.

POWER TIP

Try to keep your personal problems personal at work.

Rhonda, an accountant, complained that several of her co-workers, all women, have no restraint when talking about their kid's or husband's problems at work. "Most people seem genuinely interested," she admitted, "but later when something goes wrong with their assignment or work product or if they call in sick, people think it's due to family conflicts and problems at home."

Color My World Perfect

When you miss the mark on something, do you accuse yourself of "not being cut out" for your job and ruminate on it for days? Do you compare your life to others and think you're not as smart, pretty, fit or happy enough? Do you feel like your work must be 100% perfect, 100% of the time?

An abundance of research suggests that perfectionism is something that largely affects women. Most studies suggest that women are more

likely than men to experience feelings of inadequacy at home and work. And even a larger percentage feel they fail to meet their own high standards. And, it gets worse. Studies report that most women will only apply for a job when they feel they have 100% of the qualifications while men apply for the same job when they have met only 50%.[4]

Perfectionism is not healthy. It can cause anxiety, panic attacks, depression and even eating disorders. Perfectionism starts at an early age and is a huge problem for young girls and women in America. Sadly, over 65% of high school girls are on a diet to lose weight.

Janice, a director for a large consulting firm, summed it up; "I had to get off social media. It was getting to the point where I thought it was damaging my health. I had to delete my Instagram and Facebook accounts because I would get depressed when I saw friends who looked better than me or were doing such amazing things in life. The pressure to be perfect was at the heart of my depression. I am an educated woman with a good perspective on life, but it was killing me to see so many of my friends living perfect lives. I was feeling worthless and isolated compared to them."

POWER TIP

If you suffer from perfectionism, try getting off social media for a while.

So how does a woman combat her need to be a perfectionist? Many psychologists advise that it's important for a woman to know that it's one thing to be their best and another to be perfect. Overcoming this debilitating phenomenon is not easy and takes a lot of introspection, self-reflection and vulnerability

If you suffer from life's perfectionistic curse, do a simple reality check. Like Janice who shared that social media was causing her to feel anxious and depressed, take stock of where you are in life and ask

yourself if perfectionism is negatively affecting you. If so, study reasons why this may be happening and think about strategies to help you overcome the need to be perfect.

One way to accomplish this is to reach out to the experts in the field such as Dr. Brené Brown who has studied vulnerability, worthiness, shame and courage for the past decade. She uncovered that the sheer power of vulnerability and how living wholeheartedly is completely transformative. Part of living with a whole heart, Dr. Brown says, is the ability to cultivate authenticity, a topic she explores in her book *Daring Greatly.*

*I encourage you to read this book cover to cover and begin your own transformation. Her message is a game changer and will set you on your way to conquering internal fears that could be holding you back in life.

*Brown, B. Daring Greatly: How the Courage to be Vulnerable Transforms the Way we Live, Love, Parent and Lead, (Avery, 2015)

INTERVIEW

Corinda
Age 20
Sheet Metal Union Worker

Corinda is very young on the outside but very mature inside. For a 20-year-old woman Corinda has already made some serious and different career choices. Corinda has completed her training and is now an apprentice for a sheet metal union. When she is on a site with 200 workers, Corinda may only find herself accompanied with three other females. She is not intimidated by her work environment and finds all aspects invigorating and challenging. Corinda has shown her ability to persevere among men three times her age in the same field. While Corinda is still young, she is determined to conquer the physical challenges of the job but would like to move into a foreman's position or similar role. Corinda demonstrates utmost strength and courage while managing her career and future life plans. We celebrate this young woman's commitment to her passion and envision much success coming her way.

Thank you for spending time with me today. Why do you think you have so much confidence at such a young age?

I got my confidence from my stepfather. I never really wanted to do anything with my life, and he would talk me into doing things and get me thinking. Because of his influence I started to come out more and be myself and started thinking about what I wanted to do with my life. Because of him I feel that I have more confidence in work and with my lifestyle.

Do you still look to him for support and guidance?

Yes, he's my mentor and I ask him for advice all the time. Yesterday, he took me to a financial meeting to start saving more money for the future. I wouldn't have done that unless he set it up for me.

You are very fortunate to have him in your life. Was there ever a time in your life when you didn't have self-confidence?

Yes. I think I was in late elementary school, maybe going into middle school. It wasn't until my junior year that I started feeling comfortable with myself and more confident.

I hear that a lot about young women's confidence taking hold in high school. Please tell me about your career.

I'm in the local 17, it's a sheet metal union. I install ductwork. We make our own blueprints and do CAD work with the computer and drafting. We also do what's called TAD, that's testing and balancing which involves testing the airflow into a building through the ductwork to see if a room gets enough air.

When did you decide you wanted this career?

I decided early on in my senior year of high school. I took HVAC (Heating Ventilation and Air Conditioning) when I went to high school. This was a whole different trade. They put me in a Co-op program, and I ended up in sheet metal for some reason instead of doing HVAC. I ended up liking it better. That's when my stepfather talked to me about trying to get in the union. I was looking into it and saw all the benefits and realized that's what I wanted to do. I knew how to make all the parts from being in school, but I didn't know how to install. I figured I could learn that on the job.

How physical is this job?

Very physical. I'm in pretty good shape but some days I'll be really sore. My feet will hurt. You're always on your feet and you are never

sitting down. You're always lifting heavy stuff. You have other people helping you too but it's very physical. You go up and down ladders.

What are your coworkers like in this environment?

There're some good people and then there's some that I don't know how to describe. They're just angry at life and probably can't take out their frustration at home with their kids and wife. So, when they go to work, they take it out on the workers around them. Right now, where I'm working all the guys treat me really good. We all have a close bond. We never fight with each other. But I know in this trade other people do so I am lucky.

When you're on a site how many women are working?

Ratio wise? Well right now I'm on a brand-new building that has probably 200 workers. We have three women working. There's me, a plumber and a woman who installs windows.

How does that make you feel?

I mean I'd like to see more women, but I just know that it's not one of the female trades. It doesn't really bother me that much because I know that most girls don't want to do this. I would still like to work with more girls because it would be nice to show people that we can do this job.

How do you show confidence and courage when you're in that environment?

I feel confident when one of the guys will tell me to go up there and drill something. I'll think to myself; I know I'll go do it, but I know they are thinking I'm just a 20-year-old girl who they love telling to go up there and drill this hole in the ceiling. You'd think they'd be asking the 30 year old guy who has huge muscles and works out every day to do that. But I'll go up there and drill the hole. It's nice to know that I have the confidence to do what the men can do. I went to a women's

trade conference where I received a sticker that says '20% girls in 2020'. I wear that on my hard hat. Sometimes I wear shirts that are girl shirts and then girl power shirts.

Only 20% in 2020? Lots of work left to do. Tell me about the women's trade conference.

We network. Last year we went to Seattle and met women from all the states. There were over a thousand women there. It was crazy. There were all these women representing the different trades.

What if a male worker offers to go up the ladder for you, what do you do?

I will just go up the ladder because I know I can do it and they say, "Okay, cool." Other times when I know I can't do something, I'll be like, "Okay you can do this for me. Thanks."

Do you participate in any other types of women networking groups?

Other than that conference in Seattle we don't really go to events like the carpenter's union in Boston. We ask one another if we want to have a female committee, which I think we should do but we haven't talked about that yet.

If you could form a committee would you include both women and men?

Yes, for the networking. I highly think that men should be involved in networking, to spread more support. Because if it's just women, we can't get the word out as well. I feel if we had men who helped us get the word out about women working well in this trade then other men would think it's not that bad for a woman to be working the trades. Some men don't like having girls in their trade because there are still some old guys that are old school who think we shouldn't be here.

Do you get the feeling they may feel threatened by you?

Oh yes. They do because they think when they retire, we're going to take their jobs and they don't want to see that happen.

Has there ever been anything in your work environment that made you feel unsafe or uncomfortable?

Yes, there was this one job in Boston. There were four bathrooms. Usually a woman has her own bathroom with a lock on it, a key or code. But this job didn't have one for the women on the job. I usually don't use the bathrooms on the job because I just don't. This one time I went in there to wash my hands. When I looked up there was no mirror. It was just plain sheetrock, and someone took a big black marker and wrote, "I like the tin knocker's ass" and all this stuff about me. I knew they meant me because I'm the only girl tin knocker there. I felt uncomfortable but right away I grabbed my foreman and showed him the bathroom. He took pictures and reached out to my company's boss and my outside super. We were all communicating in an email together.

Were you more afraid or angry about the situation?

I was more mad than afraid. I wanted something to be done about it. I was uncomfortable working at that job. I knew one of the guys I was working with wrote it, but I didn't know who. It was just weird having to work next to them not knowing who wrote it.

I'm very sorry that happened to you. What did your supervisors do to remedy the situation?

They emailed everyone about the situation. When I got home from work that day the company and my boss said if you go in the bathroom tomorrow at six o'clock in the morning when you start work and it's not painted over, I will personally come over there and paint the bathroom wall in front of all of them. When I walked in the next morning some workers were painting it.

Were you satisfied with the outcome?

Yes. As a result, they gave us our own bathroom and a key, and I was happy. I was happy they did that because two days later they had to do some finish work on the job. Five girls were brought in to clean up the

job site. I'm happy that it happened because now they can use a girl's bathroom and I'll have one also. They also gave me a formal apology about the incident which I thought was good.

How do you influence others at work?

I think I have influence at work because I'm so young and they're so amazed that I get up every day at 4:30 in the morning and I show up with everyone at work. Most of the workers have kids that are literally my age and some of the workers say to me, "My kid is your age and won't even get up at noon to go to work and look at you!" I am not sure if that would be considered influence, but it makes me feel good about myself that these guys respect me in some way.

What suggestions could you share with young women about gaining equal access and opportunity no matter what career they're in?

I would tell young women today that they should just go in there and act like you know what you're doing and don't think about what other people will say or think about you. Even if it's a male dominated trade don't be afraid about what other people are saying about you. Just go in there and just do your best and don't worry about a thing. If you know your trade, people will begin to respect you.

Where do you think you'll be 10 years from now?

I would like to be a foreman, run the worksite and manage the workers. I don't want to wear my tools all my life and kill myself. I wear a tool belt and a hard hat now but if I was a foreman, I would only wear a hard hat.

Do you spend a lot of time on your personal appearance?

I don't wear makeup. When I get ready for work or go out, I just take a shower and brush my hair. I think people don't really need to sit in front of a mirror for an hour and apply all this stuff just to go out to the grocery store or whatever. I feel people look better in their natural skin

and should feel good. I feel weird when I wear makeup so I'm the opposite of other people. What I mostly stress out about is what to wear when I go out and if my outfit looks good. That sort of thing. I don't stress out about my hair or makeup. I'm always buying four outfits and then tear my room apart when I'm trying them on if I go out to dinner or a fancy place. That's hard for me… to pick the right outfit.

So, looking ahead, do you ever think about having children?

I do want to have children and would only like to have one. That's what I think right now so it could change. I don't think about this very much because I am in my early twenties and have a lot of time to think about it. But I would like to have a family when I'm older.

Do you think men have a greater opportunity for advancement in your field?

Yes. Men advance more in this trade because it's the 'higher ups' who advance other men. They can see that men have more power than a female. We don't have any female foremen that I know of. I know that if I ever became a foreman the most trouble would be telling people what to do. I'd have to get used to it, but that's just because I'm a female and they're just not going to listen to me. I still want to become a foreman someday and think that it will happen for me.

If you were to get that position at some point in your career, would you be unique?

Yes. When I go to these trade shows I see women get up and tell the girls that they are a foreman and that they run a crew of 22 guys and they are only about 40 years old.

So, you feel you could get to that point within 10 years?

Yes, I definitely could. I've only been in this career for three years. I feel when I'm older and learn more about this field that I will be able to think about a higher position. I am learning and working on being able

to speak up more in this job with all men. I am confident that one day I will be a foreman or something other than a sheet metal worker when I get older. I love what I am doing now.

Let's talk about financial security. You mentioned having a meeting with your stepfather. What are you doing to gain personal financial security?

I don't pay rent since I live at home. A couple of months ago I wanted to give my parents some rent money, so I have been giving them $200 a month to feel I'm paying for my rent. They're putting it in a savings for me.

What are your plans for living somewhere else?

My parents and I made a deal that after five years of my apprenticeship, I would get my license and then move out. They would allow me to live with them until that happens. They want me to save money for that. I am in my third year and have two more years to go. I am very lucky to have this arrangement with my parents. My boyfriend wants to get a condo in two years. We are planning for that too.

What a wonderful arrangement to get started in life. Did you learn anything in high school or postgrad about money management?

No, nothing. When I did my taxes for the first time this year, I was very confused. I didn't know what everything meant. They don't teach you anything like that in high school. I never had a financial course. I never learned about using credit cards. I still don't know how they work, and it confuses me. I think they should offer this type of training in high school for kids. Everything I know about finance I have had to learn on my own after graduating.

Finally, what's the best advice you could give a young woman about gaining self-confidence and power in life.

My best advice to young women is not to think about other people so much, not selfishly but don't go out of your way to please other people.

Think about yourself and don't worry about what others are doing or saying because that's what I used to do. Now I feel so much better with my life after I stopped doing that. I can focus on my being and what I'm doing and not someone else and that makes it better. After I thought to myself that I am doing good and that I am a good person then things began to change for me. That is something a young woman should keep in mind.

Thank you for taking the time to speak with me today. It was a pleasure to get to know you and learn about your career working in a profession mostly held by men. Keep supporting those younger women!

I enjoyed talking about my journey. I am still very young but think I have a lot to offer women who want to enter the trades.

After 16 months on the "Wedding Diet"
Belinda was overtaken by an insane hunger
that mysteriously transformed her slimmed
down bridesmaid body into Maid'zilla and then
she ate the bride.

This Old Dress?

One small action that shouts confidence is the ability to take a compliment. Most woman have trouble with something so simple and often deflect praise by saying, *Oh, this old dress*, or *It was nothing*. These delimiting responses often occur when a woman feels she doesn't deserve the praise and instead turns a compliment into a way to point out her flaws. Much of this behavior stems from a woman thinking she's not worthy.

Then there's the issue of who's awarding the compliment. For women, there's nothing quite as terrible as being perceived as cocky or too confident by another woman. According to one study, "only 22 percent of compliments given from one woman to another were accepted but compliments from men were accepted 40 percent of the time."[5]

Take a compliment with style and simply say, "Thank You!"

Let's get over it. Take a compliment with grace and simply say, Thank you! Hannah a social worker admitted that learning to take compliments was a huge undertaking. "I had to pause and think when someone complimented me on my weight loss or praised me for a recent accomplishment. In my former life I'd say something to negate the compliment, like *I still need to lose 10 pounds* to deflect the attention. Now a simple 'thank you' with a smile works every time."

Never Let 'Em See You Sweat

While crying often denotes weakness for women at work, sweating in a tense situation cries out there's a phony amongst us. When the office goes on lockdown, do you take a deep breath and go into action or do you act in a panic mode? Think about the last time your boss was in a crisis, what did he or she do that gave you confidence in their leadership? Did they walk slowly, speak in deliberate terms, and appear to have a plan in mind? Yes, they did. Next time you oversee a crisis, no matter how big or small, take stock of yourself and your actions. Everyone will be looking to you for strength and leadership.

POWER TIP

Try to look cool, calm and collected in an emergency, even if you're scared to death.

Roberta, an executive director declared that remaining calm during an emergency was something she had to think about. "One day a loud noise that sounded like gunfire was coming from a distance in the office. I hate to say it, but I lost it. I started running around, screaming, and eventually grabbed a male coworker's arm for support. I knew people were looking for direction, but I was scared to death. The gunshots turned out to be metal chairs falling off a counter. As the person in charge of this office people expected more out of me. After that experience, even if I am afraid, I try to take stock of myself to project confidence when things go wrong in the office."

Excerpts from Ryder & Capellino. 92 Tips from the Trenches. (Delmar Publishing, 2014).

Name That Fear

Do you ever wake up in the middle of the night and worry about mistakes you think you made? *Did I buy the right jeans? Should that word in my report have been 'fifth' and not 'five'?* Do you ruminate about them and can't get back to sleep? While some fears are useful the majority are not and can cause a person to lose purpose, strength and confidence.

We know fear evolved to keep us safe. For example, if you are suddenly confronted in a dark parking garage by a suspicious man and get a bad sense, fear will cause you to run away or scream for help. Those are the good fears.

It's the bad fears that wake you up in the middle of the night that cause you to lack courage and avoid risk. So how does one begin to combat these fears? The most important strategy is to identify the fear. Many psychologists tell people to simply write down each fear on a piece of paper. This causes the brain to focus on each fear individually by offering up a backup plan. For example, if you were to write, 'fear of public speaking' your brain would then shout out *prepare in advance, deep breathe.*

Next, it's important to determine where your fears come from so you can take steps to gain control. For example, some women fear rejection by the opposite sex because of experiences they've had in their teen years. To counteract this fear, women are encouraged to drill down and think about situations where they were not rejected and were welcomed by the opposite sex. This is a simple strategy to begin managing your own fears.

What if you can't find the source of a fear? Then it's likely your fear could be coming from a memory. For example, if you are deathly afraid of spiders and don't know why, your fear could stem from something that happened in your past. The mere process of actively thinking about

these fears won't make them go away but will help you recognize how they may have evolved from some experience. The big take away is not to allow your fears to cripple you.

POWER TIP

Face your fears by zoning in on their root causes.

Many women talked about facing their fears and having courage. Martha acknowledged that the most courageous thing she had done in her life was switch professions. "I graduated with an undergraduate degree in computer information systems followed by a master's degree in information and communication sciences. I immediately got a position with AT&T Global in Chicago. After a while I thought this job was eventually going to be my death. I was afraid to move to another job, but determined it was basically rooted in my fear of change. The compensation was excellent, but I knew I could not stay in a cubical doing middle management. It just was not for me. I cried every night and my stomach hurt every day. So, then I took a chance on myself. I managed to confront my fear of change, gather up some courage and find a new career."

Ericka disclosed her most courageous act was to walk away from an emotionally and physically abusive marriage, "I had a nine-month-old infant, while financially dependent on my then husband. My courage came from being a mother! It came from the conviction and belief that every child deserves to be raised in a safe and loving environment and not witness domestic violence. I fought the battle for our safety with tenacity, while being placed under the state's protection program. It was the starkness of my child being a witness to this abuse that led me through a process of introspection, self-analysis and self-realization."

Two characteristics displayed by these courageous women were

that they had confidence in themselves and believed in their ability to succeed and overcome their fear of the situation. Remember confidence comes from many sources including knowing that you have good friends, a good education, or the ability to find solutions for a problem that needs solving. Confidence can bolster your courage and make you more willing to address fears that can cage you for life and prevent you from attaining the life you deserve.

Yes, But

Authenticity is the number one trait admired by most people. And listening with authenticity is one way to gain admiration and trust. How do you do that? It's easy. You listen to a person as if they are the only person in the room. You look them in the eye, nod your head in agreement, ask clarifying questions and smile.

POWER TIP

If you catch yourself saying, "Yes, but," you are not listening.

Victoria, a computer specialist reported that her boss, a female CEO of a large tech company is her absolute hero. "One of the things I admire most about her is when she speaks to me, she acts like I matter. I want to be like her and make people feel important just by listening."

Most women love to talk. As you know, there are critical speaking engagements such as departmental updates, award ceremonies, planning sessions and board meetings where talking is required. One of the most admired characteristics of a confident and empowered woman involves the art of listening. The question then becomes how does one engage in authentic listening when our roles involve so much talking, offering advice, directing people, and giving

orders? One important technique involves your willingness to have an open mind to hear different sides of an issue.

The most difficult habit that can block artful listening is holding back on the urge to jump into a conversation to voice your own opinion. We often believe that what we have to say is more important than the speaker. However, if you catch yourself jumping into a conversation with the words, *Yes, but* you are not listening. *Yes, but* responses mean you can't help yourself and should be a warning that you need to work on learning to listen. Also try to use visual cues such as nodding your head, leaning forward, making eye contact, taking notes and offering affirmative "uh-huh" responses to show the speaker you are listening. These tactics are a good first step to artful listening.

Excerpts from Ryder & Capellino, 92 Tips from the Trenches. (Delmar Publishing, 2014).

Step Away from the Computer

Face-to-face networking is vital if you can make it happen in busy times. The key is to step away from your computer and get out and meet people. Be the first one to show up for a meeting and greet everyone. Make networking in person a top priority over using social media! The more people who see and engage with you, the stronger your presence becomes in the workplace and throughout your community.

POWER TIP

If you're shy, network in person with a buddy.

Patricia, a director of a chemical lab acknowl-
edged that making close personal connec-
tions rather than assembling a "list" of contacts is her preferred style. "I value personal connections so highly and know it's

important to make professional contacts for maximum advantage in my career. In my opinion in-person networking is more effective over the long run than social media."

Karen, a government worker confessed that she is shy and hates to network in person. "I'm an introvert so I love social media for networking. But when the opportunity arises, I know I need to get my butt out of my seat and meet some people. One trick I've used to overcome my shyness is to network with a buddy. It's much easier than going solo."

POWER TIP

Make face-to-face networking a top priority!

Ericka shared two valuable networking tips she uses when networking. "I learned somewhere that if there's a nametag, you should wear it on the right side of your upper body/chest area. When you reach for the person's right hand, that's where they look first. Then use the person's name in the conversation. It helps to remember the person's name when you say it aloud, and it also makes the person feel you care. I do this all the time and have made some positive contacts over the years that have not only helped my career but have turned into good friends."

Shine Those Pearly Whites

Candice, a human resource director is known for her positive atti-tude and infectious smile. Jamie, her colleague, shared, "When I see Candice in a room, I nudge through people to be closer to her. Just being near her for a minute can turn a bad day into something positive. When you talk about a woman having confidence and power, Candice wins the prize."

Forbes reports that people who are happy at work are 180% more energized than their less content colleagues, 155% happier with their jobs, 150% happier with life, 108% more engaged and 50% more motivated. Most staggeringly, they are 50% more productive too.[6]

POWER TIP

Think positive! Compliment people on good work before offering any criticism.

As a woman attempting to move up the career ladder, smiling and positivity should be a no-brainer. And it's so easy to incorporate into your everyday agenda. Smile, think positive, and compliment people on good work first before offering any criticism. Believe the glass is full before coming to work. Think to yourself, when was the last time you admired a boss who was a naysayer and grump? Smile and the whole world will smile with you.

Stand and Deliver

POWER TIP

When speaking in a large group, stand up and state your name and position!

A small but important tip to gain presence when speaking to a large group is to stand up. When asked to speak, stand up and state your name and position and then speak. Of course, this requires some degree of emotional intelligence to know when and where this is appropriate. You would be surprised how many women have never thought of this. Watch other colleagues who have a strong presence; they stand up and introduce themselves when speaking or asking a question in a crowd.

Heather, an executive in the medical field, disclosed that she recently attended a workshop on women building their executive presence in which this strategy was shared by the presenter. "I tried standing up at a large group seminar the following week. There were about 200 people in the room, and I wanted to speak on an item. I stood up, announced my name and job position and began speaking. Every head turned to look at me. At the time I thought this was gutsy since no one else was standing up when they spoke. A few minutes later another seminar participant, a man, replicated my strategy. Aha, I loved it."

Time's a'Wasting

Punctuality is rated #1 by CEOs across America for hiring and promotions. Think of all the benefits arriving on time can do for your image. People have a huge respect for punctuality as it communicates that you're on top of things, organized, and can be trusted. Taking punctuality a step further signals to people that you value them and ultimately value yourself.

Elizabeth noted a story about a woman whose only mission was to become the next CEO of the company. "She had everything going for her except one thing; she was always late; late for work, late to meetings, even late for acknowledging birthdays. Despite all her good qualities and performance on the job many believe she was continually overlooked for advanced positions in the company due to her disregard for punctuality."

POWER TIP

CEOs rate punctuality the # 1 skill in the workplace.

Erin, a stay at home mother shared a similar story about a woman in her book club. "There's eight of us in the book club and one member is always late. Not just a little late but late, late. You'd think we shouldn't care about this, after all this club is supposed to be fun and it's voluntary. But this woman has built up such animosity in the group that when she's not on time we take bets on when she'll arrive. I have to admit, she makes me mad too."

It was about time someone in operations approved Alicia's requisition for some comfortable office furniture. After all, she does sign everyone's paycheck.

INTERVIEW

Shay
Age 28
Healthcare Banker and Consultant

Meet Shay, or should we call her Super Woman? This young woman has a very confident and courageous lifestyle. Her power is just beginning to form. She is connected with her career, education advancements, family, friends, and spiritual life. Her life hasn't been without sadness or derailment but in each instance, she has moved forward and pushed beyond those hard times. Shay has incredible amounts of energy. She does not waste one moment of her time on this planet. She is a one of a kind super smart woman and passionate about her commitments to the planet and others. With all the endeavors she's been involved with she never misses a beat to stop, take a breath and show kindness. We salute you Shay and wish you great things to come.

You are a very confident young woman. Can you share anything that has contributed to your self-confidence?

One thing I do to work on my self-confidence is to be proud of the small wins. Even if that means waking up early or going further than you want to on your run or being proud of a conversation you had with people in upper management. Working on my self-confidence allows me to think about the small things that add up to being proud of myself.

You seem very energetic so let's start with wellness. Can you describe any current activities that influence your health today?

I believe health and wellbeing is a multidimensional concept. For me, there are three prongs that I think about- mental health, physical

health, and spiritual health. The way that I focus on those three tiers varies. In terms of mental health, I try and practice self-awareness exercises. When I think about my strengths, my weaknesses, and how I act in certain situations, I try to challenge myself to be very empathetic for others, slow down and be patient. Another way that I practice my mental health is meditating for five minutes before I go to bed to slow down and calm my mind. I also say "I love you" whenever I feel the need. So just recognizing love for someone else.

Let's talk about beauty and personal appearance. Do you spend a lot of time trying to look good?

So, this one's funny. I grew up in a function over fashion environment where beauty is in terms of what I wear; the two are very similar. Also, a lot of people spend a ton of money and time on their outfits and their physical appearance but I focus more on my natural being. I don't spend a ton of money on makeup, but I get my hair highlighted because I identify as a dirty blonde. But in terms of liking fashion, that's not a big part of it. However, as I was saying before about my physical health, I focus on staying fit because a fit and strong body is attractive to me personally. I feel I'm in control and taking good care of myself. They are both one and the same to me.

That's an interesting perspective. Do you ever feel that you are taking on the whole world and there's no time to even think?

Definitely. So right now, I'm working a full-time job, getting my MBA at night and work two side jobs. At the same time, I'm trying to invest in friendships, families and managing a long-distance relationship. I feel at times that I'm burning the candle at both ends. And lately I haven't been able to get ahead of that. I feel it when I can't sleep well. I am very lethargic in the morning. I typically wake up and work out in the morning and so the days that I can't get up and do that, I don't feel myself. I try to prevent this by going to bed earlier and shutting my phone off before I go to bed. Lately I've been working a lot, so I try

to go straight to bed at 11:00 PM. I know that's not healthy and I'm working on that. I see the change in my energy levels by the end of the week and I crave for the Saturday morning sleep in.

Oh yes, the Saturday sleep in. I remember those. What's the best advice you ever received?

There are a couple. First, follow your passion and invest in your passion monthly, daily, on a regular cadence. Know who you are and work off those strengths. Never go away from a job but go to a job. Then give and get hugs as often as you can.

What advice would you give young women today on gaining self-confidence?

Every experience teaches you something and you must be conscious of what you learned in each experience. I think the practice of knowing the good and bad of what has happened to you is valuable when gaining self-confidence. Your strengths allow you to be competent in your own self and your knowledge of self. I think that's good for when the little things add up. One practice I would recommend is at the end of the day write down two things that you're proud of or did well and then one thing that you want to work on or improve. I think by knowing 50% of things you're proud of and building yourself up is a good place to begin. Then you're able to use that power to move forward on areas you want to improve. I also think it's important for women to clean up their conversations and speak with intention. Don't apologize for things you did or said when you should not be apologizing. This is important.

What do you ever worry about in your young life?

I worry about financial stability and having kids. Right now the way the market is turning, it's hard to own things. You know, our generation rents everything. We rent homes, rent cars, we don't have our own assets. The cost of education and cost of living is rising significantly. And honestly even the fact that owning a dog can be overwhelming

kind of scares me. Having financial stability to be able to do things and lead a great life for myself and my children when I have them is a worry of mine.

So many women talk about that same worry. Can you recall a time when you were in trouble with something, let's say at work or with a friend?

Yes, I can share the situation when one of my roommate's boyfriend started living in our apartment and it was really challenging. He was living at home. He didn't have a job. He was unemployed and was essentially living at our apartment full time. He was messy and rude. We didn't get along. Our roommate asked if he could move in full time in the spare room and I essentially said, No, we'd rather not. We want to keep this place to ourselves. We didn't get to the root of the problem at first but then we asked her if she was okay and if she needed help.

It turns out that she was running into financial problems and a solution was to have him help her out with the rent. I think sometimes just asking questions instead of rushing to a conclusion is the better strategy. We were able to empathize with her and understand how we could help her first. It allowed us to be more understanding and patient instead of cutting right to the chase that they were using and abusing our apartment. This strategy helped our relationship grow stronger and taught us that if we ask questions and slow down it allows for everyone to be a bit more honest.

Sounds like you got to the heart of the problem without causing hard feelings. Can you share a story when you exhibited the most courage in your life?

Well this is twofold. One time in my life where I needed courage was when I moved to San Diego for a job promotion, even though I didn't want to go, and I didn't know anybody. It was scary. I had never been to Southern California before, other than for an interview. I had to just trust the process and take a risk. And then the second part, six months later, was having the courage to move home and be the sole caretaker for my dad who had cancer. That was uprooting my life twice in a matter of

a year for significant reasons. It was one of those things where you put everything aside and you must trust the process.

That must have been difficult. What do you currently do for work and what steps did you take to get to this level?

Right now, I'm working in commercial banking and I'm in an underwriting venture with debt facilities to biotechnology and diagnostic companies. This was an opportunity that arose through connections from my undergrad program. The steps that I took to get to this level were all about networking and becoming an expert in your field. And following my passion aligns with this. I'm really interested in the healthcare space. It allows me to be passionate about researching companies in the market and understanding what's going on with financial trends so that I can have productive and consultative conversations with clients.

When following current events, how do you stay on top of everything that's going on in the world and still maintain focus at work?

I generally stay in touch with current events. I listen to NPR when I drive in the car to and from work, which I think is one of the best programs out there for high quality news. I also read the Skimm every day. Sometimes it's irrelevant, sometimes it's not. I find that I often must click too many things out of Skimm, unfortunately. But I get the gist of it. Then I also have Wall Street Journal and New York Times subscriptions and read The New Yorker. I go between those three resources either daily or every other day. But rarely am I sitting on news channels at work. So, my news needs to be quick, easy, before or after work.

What's the best career advice a coworker or manager has given you?

This is a discussion that I've had a couple of times with people. It's don't take a job or new role or join a company for what it could be in the future. Don't buy into the story, buy into what the company is now. Also try to ensure that you trust the people that you plan to work with. You can't control all these external factors that could derail the future

from happening but you can understand what the actual impact could be on you at the time. It's easy to get caught up in the future, the opportunity versus what the company is. I would keep those aspects in mind.

That's good advice. Do you have a mentor at work?

I have multiple mentors. I have mentors personally and professionally, both in my current job and in my network.

What advice have these mentors given you to succeed?

The biggest thing mentors have allowed me to do is to be honest with what I'm worried about and how to align myself with the right people and my strengths. It's nice to ask others what they see as your strengths, what they think you're good at and what they think I need to work on. Getting that feedback from someone else is important because it's easy to think, Oh, I'm so good at X, Y, Z or I'm so bad. I also think that it helps to validate where you fit into things. Another key conversation I had with one of my mentors was how to manage asking for a pay raise and a promotion. That's a conversation that's hard. I've only done it once but asking others how they've done it and how people have approached this situation in the past was helpful to put it all into perspective.

Are you working on anything to become a better person?

Patience. I'm an impatient person so I need to work on becoming more patient. I'm trying to slow down, literally. Sometimes I walk slower to help me breathe, slow down and think. That's a growing pain of mine, but I think it'll pay off.

Has the #MeToo movement had any impact on you personally or professionally?

This is an intense conversation. The #MeToo movement is important for females in that they need to speak up as individuals, whether it's other males or even females that have held them back from success. Hopefully there is tangible change happening, not only punishments

for things that have happened in the past, but a change of behaviors in the future for how to act, interact and talk to one another. As a female my suggested approach would be to find male allies and educate them. Educate each other on language to use and have this effort as a team movement. We can't be thinking about the past all the time. We must move forward to be better people to each other and ourselves. If it becomes a female versus male world, it's going to retaliate and that's not going to be productive.

You are so correct. Do you feel men have a greater opportunity for career advancement in your field?

Yes, I do. I think men and people in general find that those that operate in a similar mannerism or approach tend to promote one another. For example, in finance, there are a lot of older white men at the top. In the upper levels of hierarchies when men see lower levels of individuals acting in similar ways that they did then they'll promote them earlier. They'll tuck them under their wing. I find from a human connection standpoint, men tend to create common ground with one another faster than others. When men are at the top, they find men at the bottom that have shared commonalities. That is the biggest challenge women have right now. The men in my financial institution however are very cognizant of not just hiring for diversity, that is adding a woman just to add a woman, but know that skills are different, perspectives are different, and networks are different. It's refreshing to see them acknowledging that it's gender agnostic and they want to hire the best person. And sometimes that right person is a female.

Are you involved in any personal missions not associated with work?

I am involved with the AstraZeneca Hope Lodge here in Boston, which is a housing community for individuals with cancer and their caregivers. It's so powerful. My dad had cancer and I was so lucky to have an incredible amount of resources, friends and family, and a home that was close enough to Boston for him to get some of the best care in

the world. I could not imagine being a sole caretaker for my dad if we didn't have that. Every time I go to the Hope Lodge, I'm motivated to be positive for all the people staying there. We make dinners and cook breakfasts. I try and aggregate funds for them on an annual basis by supporting them through an annual gala and providing young professionals a way to support nonprofits even though they may not have $40,000 to support by sponsoring.

Another personal mission of mine is Swim Across America, a foundation that my dad swam with for eight years before passing away. It's a swim that benefits cancer researchers in Boston, which is cool because it connects back to my work. These cancer researchers are trying to cure cancer. Their work in the lab then translates into the biotechnology companies that I support from a financing standpoint. It's nice to get out and compete in a fun way, swimming through the Boston Harbor under the planes that fly into Logan. It hits close to home.

How important is it to have women friends in your life?

I think women tend to be empathetic, caring and open and that's really refreshing. We tend to listen really well and when you're given a space to share concerns or proud moments women listen better and then they react better. Women also tend to remember each other. In the past I've had people reach out to me and say, I haven't talked to you in two years, but this came up and reminded me of you. That is super powerful because it builds a network that continues to expand like a spider web. It's incredibly important to be able to relate to and trust other women. Like when we face pregnancy; there's so much that women experience that men simply don't like talking about. Women can talk about IUDs, getting pregnant, freezing your eggs, having children and working as a mom. I think all those things are very specific to being female. Being able to have women you trust and able to ask those questions for advice or help is super, super important to me.

Do you think it's important for women to help other women?

It's super important for women to help other women, but it's important for everyone to help each other. Genuinely there are institutions that have been around for a long, long time like men's clubs that women don't have. There are tennis clubs, racket clubs, golf clubs, it's all male centric. Women need to work a little bit harder to have more women's clubs to see and communicate with each other.

You are very involved in your community. How do you find a way to shut off without worrying about that last email?

Once you get good at a certain job or once you are fully embedded into a role or situation, you know whether that late email needs to be responded to or not. I also think it's important to put your phone or technology away before you go to bed. It's so hard. I'm not always good at it but I keeping trying.

Do you ever compare the success of your career to others in your social circle of friends?

This is super important because when I compare my career and path to others it damages my self-confidence. What I need to remember is that the resume doesn't mean success or happiness. It's about being able to come back to are you 'happy right now'. Individuals may be working at the coolest company but may be miserable because someone is harassing them or their job sucks or they work endless hours. You just don't know those things unless you know that person well. This is where I judge too quickly. I'm like, oh my God, they're so much better than me or they're doing the coolest things. I need to remember that I'm happy where I am. You know the dominoes will fall where they fall.

That's such great advice.

Thank you. If you're so miserable at something make a change. That's obviously harder said than done. That is a big challenge, especially with social media right now, whether it's career or personal. It's very easy

to showcase only the best parts of your life, whether it's professionally on LinkedIn, Twitter or Instagram; you look beautiful in every single post. I find that it's better to disconnect from those places every now and then, especially if you're in the middle of an important project. You don't have time to get distracted by that piece. With the age of social media, it's important to remember to pick your head up and come back to yourself. Remember to be grateful for what you have going on. And if you're not grateful for it, change it.

Thank you so much for sharing your story today. I believe young women will learn a lot from reading about your perspective.

Thanks, I enjoyed talking with you. I hope some of my thoughts will inspire other women. I believe helping others succeed is critical if we are to gain equality.

One day Polly said to Ester, "I'm sick and tired of ironing. Let's put our heads together and invent a fabric we can wash and wear. We can call it Polyester!"

So Sorry

Most women view saying *I'm sorry* to keep them on good terms with people and believe it helps to build relationships with their workers. Communication experts, however, indicate that the apology ritual to establish or restore emotional balance in a conversation is perceived by employees as weak or in a one-down position. When people apologize it's usually an expression of regret for having done something wrong to another. Unfortunately, women are harder on themselves when accepting or taking on blame.

One main reason to avoid the apology at work is that it tends to put you in an inferior position. Also keep in mind that it's not necessary to apologize over situations in which you have no control. For example, if the sprinklers go off unexpectedly and people get drenched coming in from the parking lot, it is quite enough to state what the problem is minus any apologies followed by recommendations to fix it.

POWER TIP

Learn to substitute "Excuse me" for "I'm sorry."

Brianna confided that one of her major accomplishments toward gaining a greater presence in the professional arena was eliminating the apology from her speech. "It was difficult not to apologize for everything. I'm sorry this happened... I'm sorry for this error. Once I noticed how much I was apologizing, I reined it in. I had no idea how pervasive two simple words could be in a woman's communication style."

If you want to check your speech on any given day, you would be amazed at how many times you use the words *I'm sorry*. This apologetic

ritual is hard to break but with a bit of practice can be accomplished. Become aware of when, where, and the number of times you use *I'm sorry* in one given day. Try substituting the phrase, *excuse me.* This replacement is not half as bad as an apology and will lessen your weakened power position. Or flip your use of *I'm sorry* into something more positive. For example, rather than saying, *I'm sorry I took up so much of your time,* say, *Thank you for giving me your time today.* Sounds better, doesn't it?

Excerpts from Ryder & Briles. The SeXX Factor: Breaking the Unwritten Codes that Sabotage Personal and Professional Lives (New Horizon Press, 2003).

Wonder Woman

Do you have a track record of getting straight A's? Did your parents always say you were the 'smart one' in the family? We live in a society that focusses on success. "Go big or go home," is part of corporate America's mantra. While there's nothing wrong with wanting the best things in life, if the bar is set too high you could be setting yourself up for failure. Many women are aware of this phenomenon and struggle with defining a realistic goal. They've read that setting the bar high will cause them to push harder, which they want. But they also know that setting goals too low can cause a lack of motivation.

POWER TIP

Don't set yourself up for failure by raising the bar too high.

"*It's all about knowing yourself and what you can handle,*" disclosed Cali. "For example, I constantly try to lose weight. A few years ago, I set a goal to lose 50 pounds in one month which looking back was ridicu-

lous. I couldn't meet my goal and started feeling frustrated and defeated. My sense of self-worth crumbled right before my eyes. Now if I'd been more realistic, let's say set my goal at 10 pounds, I would have met my goal as I actually lost 12 pounds that month."

A smart move for any high achiever is to set your goals high to motivate and inspire. But be realistic and don't undermine your self-confidence. Be smart. Strategize for success by setting goals you can meet over time. When you set a goal you can accomplish there's a good chance you will be successful. And with a little more effort you can take your goal to the next level, boosting your confidence even more because you see results. Then set another realistic goal at a higher bar.

Cut to the Chase

Why is it that women take the hit for overtalking? For years we've been stereotyped as nonstop talkers when the research states that men do most of the talking. It's all about perception and how we've been conditioned to think women talk too much.

POWER TIP

Speaking with clarity is the ability to tell your message in under 20-30 seconds.

Michelle, a senior government specialist recalls a female associate that couldn't stop talking once she got going. "We were together a few days ago and I couldn't get a word in edgewise. I think she's still talking right now," she kidded.

Maria shared her frustration with a male colleague, who in her words, *monopolizes every conversation.* "Here you are, sitting in a two-hour meeting and this guy carries on forever like he's the only person in the room. Our

group has nicknamed him "Jabber Jock."

The point is that none of these people had a chance to "own the room" or gain a seat at the executive table. Speaking with clarity, the ability to tell your message in under 20-30 seconds, is a high-level skill admired by many. Speaking concisely with a message and follow up questions such as, 'What else can I share about this idea?' is another sophisticated skill set. People turn off if the message is not clear. After a while, a nonstop talker becomes the target rather than the message taking precedence.

Finally, are you credible? Do you tell the truth and back it up with solid evidence? If you promise to follow up with something do you keep your word? Clarity and conciseness in communication can all be learned, if practiced. Before planning to speak, write down your main message point and be as succinct as possible. Know your audience and speak to your main idea first. Use an active voice and skip unnecessary details. Finally, if you want an honest assessment of your speaking aptitude, ask a critical friend for feedback.

Face Time

Do you have problems in your personal or professional life that cause nonstop insomnia? Is your boss asking too much, but you don't know how to tell him you're drowning? If your answer is yes, then you might want to consider having what's called a *Courageous Conversation* in which you speak up and express how you feel about an issue.

Most women interviewed acknowledged there were times when they should have had a courageous conversation but were too afraid. Chelsea, a retail store worker revealed that she avoided these important conversations. "I hate these confrontational discussions but if I avoid them things always get worse and the relationship dissipates over my growing resentment." In this type of

situation ask yourself what the consequences would be if you did nothing? For example, if your friend had too much to drink one night, would you be willing to confront her and call an Uber?

POWER TIP

Gain consensus with the person in advance before having a courageous conversation.

When having these conversations, it's critical that you don't attack the person or make the issue about you. Be authentic about sharing your feelings and listen to the other person's side of the story. Seek to come to a resolution for the benefit of the relationship rather than for the individual. Experts suggest that before beginning a courageous conversation it's important to ask yourself exactly why you think you need to have it. What are you hoping to achieve and what gives you the right to initiate the conversation? Is your life in danger? Are the men in your organization making more money in the same position than you? Prepare yourself to be uncomfortable as most people don't want to deal with controversy.

One key strategy is to find agreement between the two parties for holding the conversation. If the person is reluctant to talk about the problem, you will not be successful. If you gain consensus on having the conversation, begin by telling your side of the story and then invite the other party to join in. While you can plan and prepare all you want for these talks you cannot control what people will say or do. Most people don't feel comfortable working on problems so be prepared for that.

In the case of the drinking driver, the conversation will be quick and deliberate. However, working with a boss to unload some work is another story. Don't expect a courageous conversation will get immediate results. Be realistic about your expectations and be courageous. If you want to perfect this skill set even more, read Pattern's book, *Crucial*

Conversations, Tools for Talking When Stakes are High, an excellent resource recommended by many women's groups and universities.

Do You Hear What I Hear?

Almost every book on communication mentions women's use of *tag* questions or qualifiers. Whether women use them more than men is not clear. The important fact is to be aware of speech mannerisms that can be misinterpreted. Typical *tag* questions include, *This needs to be accomplished by noon. Is that okay with you?* or *We need to be at the meeting by 8:00 A.M. Is that a problem for you?* The issue is that both sentences can be interpreted as a window for choice. The receiver of the remark may say, *No, it's not okay with me,* or *Yes, it is a problem.* Nonassertive speech patterns lesson a woman's perceived power both in her personal and professional environment.

Another factor that's a greater drawback for women than men is the use of polite speech. On the one side, politeness shows a high regard and respect for one another. That's not bad. Some cultures covet this behavior. But there are times when too-polite speech lacks the necessary assertiveness or forcefulness.

POWER TIP

Stop saying, "Is that okay with you?" Nonassertive speech patterns lessen a woman's perceived power.

Shelby mentioned that she sometimes feels inhibited to ask for something boldly. Instead of saying *Let's go to lunch,* to a coworker she catches herself saying something like, *Oh you're probably too busy and don't have time to take a break.* "I recall asking for permission to speak in a meeting last week saying, *I know*

you've probably heard all there is on this topic, but would anyone have a problem with me sharing a different version of the plan? I immediately realized this type of communicating lacks power. I'm now more conscious to speak in a goal-oriented style so my message can be heard more effectively."

Excerpts from Ryder & Briles. *The SeXX Factor: Breaking the Unwritten Codes that Sabotage Personal and Professional Lives* (New Horizon Press, 2003).

Rumor Has It

Gossipers in the workplace are often embraced as entertainers but shunned as professionals. We have all learned there are different styles and rituals in how men and women communicate. Where women are more inclined to speak and hear as a means to connect and share intimacies, men view communicating as power, status and a measure of independence.

Gossip as a means of communication for women has always been one avenue to power. Through gossip women could control norms, track individual behavior in relation to the norms and build community. Gossip, however becomes a problem because most people think gossipers can't be trusted. While the information contained in the rumor mill can be important for career positioning it's important to distance oneself from the source of that gossip.

POWER TIP

People think gossipers can't be trusted!

Courtney, a banker, revealed she finds gossip a way to gain important political information about the company. "But let's be honest, while I like getting the information, I don't have much respect for the person deliver-

ing it. I think people who share the dark side are disloyal, weak and subversive. I've never seen a top CEO or supervisor commit to gossiping."

When you hear gossip in the workplace, remember it can have some positive value. Listen intently when others reveal secrets but never comment directly. And be aware that not everything you hear through gossip is totally accurate. Finally keep in mind, if you don't want it repeated, don't say it.

Excerpts from Ryder & Briles. The SeXX Factor: Breaking the Unwritten Codes that Sabotage Personal and Professional Lives (New Horizon Press, 2003).

Mother, Please, I'd Rather Do it Myself

When you delegate a task to someone, do you ever feel frustrated and disappointed in the results? Do you tend to horde work leaving you drained at the end of the day? Many women share that delegating work to others makes them feel as if they are losing control of a situation.

The most ironic explanation that people give for not wanting to delegate is the perception that they don't have enough time to effectively explain the task. Amber shared that she handles all the finances in her relationship. "It would take too long to explain things to my husband. While I wish he would take more interest in what we owe and how to pay the bills he continually plays stupid on the subject, which worries me overall. What if we miss a mortgage payment?"

Many women don't like giving up a task to another person for fear that it will go bad and reflect back on them. Erin, an operations specialist, disclosed that years ago she messed up in an interview when asked to talk about her weaknesses. "I don't like to delegate," she said to the interview panel. "I'd rather do something myself to make sure the job's done right." When one of the panel

members suggested she could get more done if she delegated, she dug in deeper, "I don't think so. If they mess up, I'll just have to do it over. I'd rather work some overtime."

In retrospect Erin conceded that her interview blunder not only lost her a new job opportunity but opened her eyes on the aspect of delegating. "I started thinking that I can't do it all. I was buried in work and needed to trust myself and others if I was going to have a life outside of work. I learned it's important to delegate and there are positive ways to make that happen."

POWER TIP

Stop thinking you'd rather do it yourself because it'll get done right!

The first step in delegation is to know who's willing to take on the task. That's key. Then assuming they have the right attitude and skill set to take on the task it's important to thoroughly communicate your intentions on what needs to be accomplished. Finally, and this is where trust comes into play, follow up on the person's progress to ensure success but be sensitive to their needs and not appear as if you're micromanaging.

If you invest in people to do their best and trust them, you should obtain the desired results. Delegation is one of the most valuable skills a woman can learn but takes practice. By following some simple steps, you can learn how to decrease your fears and still feel in control of the situation.[7]

Hard as Hell

If you've read anything about Ruth Bader Ginsberg, you know this high-power Supreme Court Justice has an intense physical workout

schedule. As a woman in her late 80s RBG begins each day with a five-minute warm-up and light stretching followed by a strength training session that includes push-ups, planks, chest presses and squats.

Every woman interviewed for this book shared that they have a workout regime built into their daily schedule. According to the Mayo Clinic regular exercise leads to an improved body image, makes your heart and bones stronger, lowers your risk for chronic disease right along with your blood pressure, keeps your weight under control and reduces feelings of anxiety and depression. A side benefit from exercise is an increase in self-esteem. Just the success of creating an exercise plan and sticking to it can have a positive effect on self-esteem—especially for those who suffer from low self-esteem, as fitness and appearance improve.[8]

Ashley a public speaker shared how running preserves her confidence level. "I run 2-3 miles a day, Monday through Friday before work. If I can't manage that due to travel or conferences, I pack mini weights in my carry on and work out in the hotel. I'm addicted to feeling good. Once I had a keynote and it was raining crazy outside. I ran three miles throughout the hallways of the hotel and climbed ten flights of stairs for cardio. I'm sure my keynote would have been 'ho hum' had I not had my cardio. Most women I know have some type of exercise built into their life. For me it's not about balance but more about integration."

POWER TIP

Wake up.
Work out.
Look hot. Kick
ass.

Working out is hard as hell. But if exercise is not part of your vocabulary, stop and think out loud… *What are you waiting for?* You obviously want to be a confident, courageous and empowered woman or you wouldn't be reading this book. Let's go, get some workout clothes, create a playlist, and pick a time that works for you. Wake up.

Work out. Look hot. Kick ass!

Street Smarts

Men relish ritual opposition, the process of debate and the art of the fight. Women typically do not. For example, in a meeting when two men disagree over an issue it's common to go back and forth, each raising what they believe to be the finer points of the argument. This seems very natural for men who often derive great sport from a good argument. When women engage in this practice, however, they seem uncomfortable and take every word to heart as if it's a personal attack. They tend to get mad at the other person and plot a payback or hold a grudge. In addition, when a woman is involved in a ritual opposition situation it is not uncommon to hear insults or a snippy tone of voice.

POWER TIP

Practice the art of ritual opposition, especially with other women.

Melissa, a hospital administrator recalled instances where it seemed unnatural for women to disagree with one another. She recently observed two women arguing over the development of a creative 'Give Me a Break' room for employees. One woman wanted to spend hospital funds on the break room while the other, totally disagreed, snickering and clicking her tongue. "Actually," Rita confessed, "I found the dialog between the women enlightening. But everyone in the room sensed the tension and became uncomfortable. As a result of this incident I don't think these two are on good terms with one another."

For a woman, knowing about ritual opposition and its impact on personal power and influence is important. Mastering the skill of lis-

tening and validating other people's opinions allows for a lively debate without feeling like you are under attack. Remember, how you respond inside one of these spirited discussions is critical for your professional and personal development.

Excerpts from Ryder & Briles. The SeXX Factor: Breaking the Unwritten Codes that Sabotage Personal and Professional Lives (New Horizon Press, 2003).

How can someone so organized keep forgetting to schedule pee breaks? Isn't there an app for that?

INTERVIEW

Lucy

Age 28
Professional Consultant

M eet Lucy, a very athletic and strong woman both physically and emotionally. She takes her career seriously but still manages to make time for friends and family. Upon graduating from college Lucy, like many her age was undecided on her career path. She followed her love of sports for a period but then transitioned into finance. Later after reaching out to mentors and networking she is in a field that satisfies her and offers a challenging career. In addition, Lucy is still coaching young women in field hockey and lacrosse at the high school level. Lucy has an incredible balanced lifestyle. She organizes her days into fitness, work and social better than most. Lucy doesn't have time for negativity in her life. This is one happy woman who is on her way to fulfilling her life's positive agenda. I'm certain about this. Why, because she has an infectious smile and laugh that will forever attract a lot of people and open unlimited doors.

Can you share anything that you believe has contributed to your self-confidence?

Playing sports competitively in middle school, high school and college has been important for the development of my confidence and leadership. And being a captain for the sports teams I played on also helped. As an athlete I was able to demonstrate some leadership qualities, which now gives me confidence in my workspace. A lot of those leadership skills that I learned as an athlete translate over to the work environment. It gives me more confidence around my friends, family and people I don't know.

That's quite an accomplishment. Is there anything you have done recently that you believe has contributed to your self-confidence?

Yes, the past six years since I've graduated college, I've run five marathons. I think it's a huge challenge for anyone to run and train for a marathon. I ran five in the last five years. I try to run one marathon every year. It's takes a toll on your body but the accomplishment after finishing the race is a huge adrenaline rush as well as knowing that if I can do something like this, I can do almost anything.

Congratulations! I've never met anyone who has run that many marathons. Has there been a time in your life that you did not have self-confidence and if so, how did you manage to deal with that?

In my previous job I didn't have a lot of confidence. I was working with people that had been in the role for 10 to 20 years. They had a lot of knowledge about the industry and how the department worked. It was challenging when I approached my managers with questions, and they weren't receptive. I felt as though they were limiting my ability to learn more about the tasks at hand and the department's purpose. That was challenging going into that role. I had to catch up to people who had 20 years of experience in the industry. I had to jump right into the role.

You mentioned that you've run five marathons. Is there anything else you do as a 28-year-old to influence your health and well-being?

I try and stay active. Throughout the week I work an office job. Some days I'm in the office for 10 hours. I try and work out at least six to seven times a week and sometimes twice a day. I will go on the Peloton bike, run or do a high intensity workout.

Can you share how you feel about your personal appearance relative to how you live your life? Do you spend a lot of time trying to look good?

I wouldn't say I spend a lot of time compared to some other people in my life that get ready for work in the morning. Going to work takes me

13 minutes from the time I wake up until the moment I enter my office. If I'm going out on the weekend, I'll spend a little bit more time getting ready, but I don't really put a huge emphasis on wearing makeup and doing my hair.

Only 13 minutes? Nice. If you have a social media account what do you use it for?

That's a tough question because I don't want to say that I use social media to show off to my followers what I'm doing but instead I post times when I am having fun with my friends on the weekends. I like to make posts about the activities I'm involved in and share my posts with my friends and family who I haven't seen or talked to in a while.

What's the best advice you ever received?

I remember right before my college lacrosse team played in the NCAA quarterfinals, our coach read us a quote before the game. She said, "Be like a duck, calm and steady on the surface, but always paddling like the dickens underneath." She said this before every game and this still has a lot of meaning for me today.

What advice would you give young women today on gaining self-confidence?

Surround yourself with friends and people that are going to make you happy and support you and make you laugh. I think it's important to have those types of friendships in your life all the time.

What was the greatest change you've made in your life?

I recently changed jobs a little under a year ago. I was at the same company for four years and my role was very complacent. I was very comfortable in my role. The work wasn't challenging, and I thought for a while "the grass is always greener on the other side". I was hesitant to leave my career at my previous company because the pay was okay, the environment was fine and it was a very safe workspace. I was very

comfortable there, but I decided to actively look for a new job. I ended up switching industries in which I went from finance to the software industry, which was a huge career change. It's a better role for me and was probably one of the best decisions I've made.

Good for you, leaving your comfort zone. What is the worst criticism you ever received?

When I was a sophomore in high school, I was taking the winter fitness classes in preparation for the lacrosse season. I was determined to come back in the spring in top shape and try out for a midfield position. The varsity lacrosse coach was leading the sessions and one day I remember asking if it was possible for me to try out for the midfield spot. He simply replied, "No, I think you are too slow."

That must have been difficult to process.

Yes, it was, but I remember his criticism was more motivating than harsh. As a result, I spent the rest of the winter working my ass off every day in training. When I came back in the spring I was in amazing shape and blew him out of the water. I earned a midfield spot on the team.

That's a great story. What do you fear if anything?

I think not being able to have kids is one of my fears.

In what way?

I don't know why but getting married and being able to start a family makes me worry. One of my old coworkers struggled to get pregnant for a while and was told she had a 1% chance of getting pregnant, but then she was able to get pregnant and now has a baby boy. That was a difficult two years for her. I watched her go through that type of sadness. So, it's definitely one of my fears.

Can you share a time in your life when you had grit to take on something you didn't think you could do?

I coach field hockey on the side and for the past two years I've coached a JV team and then a varsity team at a different high school. I was a little nervous at first that I wouldn't be able to give my fulltime job one hundred percent attention that it needed. And then to coach 20 to 30 girls and give them my one hundred percent dedication as well. That was challenging at first, but I got into the routine. I also realized that coaching 20 to 30 high school girls was very important, so I had to focus on them just as much as my fulltime job.

How happy are you in your current job?

I would say I'm the happiest I've ever been at any job I've ever had. It's one of the best companies I've worked for. My team is one of the greatest teams I've been on. The work life balance is unbelievable. What I'm doing is challenging and fun. Our company's product is always changing. This aspect challenges me to learn more and more about the product so I can deliver back to our clients and customers when they have questions about the product. I'd have to sum it up by saying I love my job because I work for a great team that stresses a positive work-life balance and continually challenges me to learn more about how I can contribute to the company.

It sounds like you work for an incredible company. What are your long-term career goals?

I have a lot ahead in terms of career growth. I just started at the company and haven't been there for a full year. There is still a huge learning curve for me. Ideally, I'd want to be one of the experts on my team and a "go to" person at our company. I haven't decided yet if I'd want to be ultimately in a management role or continue to be one of the solution consultants or experts in the field.

What's the work environment like?

My work environment is very team oriented and collaborative. I work very close with a relationship manager who works closely with

the client. I also go back and forth with other consultants and bounce ideas off them. I do a lot of work by myself and obviously have my own clients, but it's very collaborative and everyone gets along. Everyone supports each other and wants to be successful.

Can you talk about your living situation?

Currently I have two roommates. I live with my two good friends from high school and we live in a high rise right in downtown Boston in the city. We live in one of the more luxurious parts of Boston, I'd say. There's a lot of development with high rises being built. The rent in this area is increasing as more and more people my age, are reluctant to move out of the city.

How important are your friends?

I have kept in close touch with my high school friends. Like I said, I live with two of them. And then a lot of my best friends are from my field hockey and lacrosse teams from college.

What advice do you have about successfully succeeding in an environment where both men and women must be recognized to get ahead?

I found it easier for myself to compete with men in the work environment because I think I have a level up from playing sports. I have that natural competitive instinct. But I also think it's important not to automatically defer to your coworker just because he is a man or not let them jump ahead of you to volunteer for something. If there's an opportunity on the table always volunteer for that opportunity. Don't let it just be the men on your team volunteering. Be loud and show your voice because a lot of the time it cannot be heard. You could be on a call and say something and then a man will take your words and say it in a different way, but still convey the same thing that you said. Then someone else will recognize what he said. You must speak up and make sure you're clear in what you're saying to get your point across.

That's good advice. How important do you think it is for women to help other women?

It's really important for me. There's not a lot of women on my side of the business at my current role and the same with my previous company. However, they were trying to increase the level of women to around 40%. It's important to support your female coworkers and managers and make sure they get the recognition they deserve in the workplace. And not just in the workplace, but in all activities.

What's the best career advice you've received from a female coworker or manager?

My most recent manager said to keep going after every opportunity and take on challenges in work that you have the capacity to take on.

Let's turn to financial security. What are you doing to gain personal, financial security?

Nothing.

Nothing? Are you involved in any work retirement programs?

I have a 401k and that's it. It's hard for a young woman to take this on based on what's happening out there in society today. First off, if you live in the city, your rent is almost half your paycheck every month. On top of that you'll have more expenses and then some money goes to your 401k. So, you rarely have any savings left after your final paycheck comes in. This is the case if you're making the average salary in Boston.

I understand. I hear that a lot. Your city life sounds very exciting. Do you have any words of wisdom for young women about living in the city.

Don't rush into living in the city. If you can, live at home for the first year after college. Save some money while you get your foot in the door at a company or whatever you're going to be doing. I would advise women to take some time to do that. A lot of women my age want to live in the city. There's really no rush because you have the rest of your

twenties to live in the city and spend money on rent. If you can avoid that scenario, that's something I would suggest. Also if you do live in the city, be involved in some activities the city offers. They have a lot of recreational sports. I've found it has been fun with my friends during the week just to break it up so you're not fully focused on your job 24-7. Give yourself some outlets.

Thank you for taking the time to talk with me. It's been interesting and fun to get a peek into the world of a successful 20 something.

My pleasure. I loved talking about this and hope other women will read this book.

Don't Forget Your Style, Girl

On any given day CEOs or administrators wear suits especially when interviewing for a new position or presenting to the board of directors or clients. Sophia disclosed that while moving up the career ladder it was critical to *dress for success*. "I literally changed my own style and wore suits every day thinking they gave me power. They did, on some days. But later in my career I learned I could maintain my individuality and dress in ways that gave me confidence and comfort (it's a long day). I didn't always have to wear a suit."

Think about it. What is your personal style and how can you merge it into a confident self? Don't be afraid to take some chances with your clothing and hairstyles. But be mindful if you sense you've pushed the window too far. In that case always ask a friend or mentor to rate your style and offer suggestions for increasing your professional look.

Many women working in startups or tech companies report that an informal dress code is encouraged. But it's still important to have a style you can call your own. Emma shared that she always tries to look good at work even if it's an informal dress agenda. "I always make sure my hair looks great. I'm not a big fan of makeup and I like the natural look so I'm good with that. Not wearing makeup also gives me more time to sleep in the morning."

POWER TIP

Find your style and merge it with your confident self!

Sonia added another perspective. "For many years, I watched my mother try to compete as an executive in a 'man's world', which at the time, meant giant shoulder pads and actually appearing as masculine as possible. I believe it's long past time for female leaders to stop trying to replicate what men

do and embrace the different sort of strength they possess; for me that happens to come along with high heels, bright colors, and a big smile."

She's Got Balls

The #MeToo movement is here to stay but men still struggle with the concept of a powerful woman. They have been forced to shift gears in their private and work lives as they encounter more women in top positions of power and authority. Many men still find it uncomfortable to report to a female superior and the idea of women having control can be disconcerting.

POWER TIP

Women are gaining access to power at expediential rates. Men need to get over it!

No wonder men still resort to all kinds of tactics to deal with their role confusion. Donna, a vice president of a large corporation shared the following reflections about making tough decisions: "It's a lose-lose situation. When I make a big decision that takes courage, I hear the gossip throughout the halls. *Wow, she's got balls.* When I make a decision that seems unlikely coming from a woman, they say, *She's too weak-a man would never have done that.* This is so ridiculous. I feel like I'm in a constant Catch-22."

Women still have a *long way to go*, but progress in the gender divide is alive and well. Men and women are beginning to acknowledge one another as team members and corporations are encouraging more women to join the ranks of power and influence. But old stereotypes can be difficult to break through.

Tracy shared that even though she has her doctorate degree, her parents still adhere to former social expectations. "At a very young age, I knew I was a feminist when I stood up to my chauvinistic father. I realized then that I'd have to prove myself in a male dominated world. In my opinion, education helped me gain the power I needed to compete in today's competitive society. Although I have earned my Doctorate Degree, my parents still frown upon the fact that I never remarried. Their opinions are based on their belief that a woman needs a husband to support her."

Another woman complained that men just need to get over it. "It's a man's world – ugh! Confidence is a huge asset when competing in a man's world. I think that women are better equipped at building meaningful relationships with others and that can put them ahead of their male counterparts. When you connect with others on a deeper level, it changes things."

And finally, Isabella acknowledged that to compete in a man's world it was important for her to become more educated and relational. "To gain equal power with the men in my profession I make sure I am well informed and educated. I also think it's super important to build strong relationships and act in an ethical manner to gain respect from everyone."

Bluffing It

For many women the fear of success and failure are two sides of the same coin. This rings true when women take on a new promotion or role and begin to worry more about failing over succeeding. This phenomenon has often been referred to as the Imposter Syndrome. The Harvard Business Review defines this syndrome as feelings of inadequacy that persist despite evident success. 'Imposters' suffer from chronic self-doubt and a sense of intellectual fraudulence that override any feelings of success or external proof of their competence. They seem unable to internalize their accomplishments; however successful they are in their field.[9]

POWER TIP

If you suffer from the Imposter Syndrome, act like you know what you are doing and soon you will believe in yourself!

Many working women reveal they are fearful that a mistake or lack of a certain skill will lead to being "found out". Olivia, a technology coordinator confessed that she never called in sick for the first year of work for fear that her supervisor would find out she didn't know what she was doing.

Liza, a city supervisor received a promotion to a higher level after one year as an assistant city supervisor. "I was afraid in the beginning that I didn't know how to do the job. I discussed this with my mentor who reassured me that most women are wracked with doubt and anxiety after moving to a new position, particularly if it was assumed by a man. My mentor told me to wear a black suit and walk around looking like I was in charge and that eventually I would believe in myself. You know, I followed her advice and it worked. I especially liked the black suit part."

*Amy, a secondary educational professional shared a different per-*spective. "As a leader, I'm leery of acting any certain kind of way. The last thing I want to do is appear false. We're all familiar with the 'fake it 'til you make it' concept, but I'm more inclined to roll with vulnerability and authenticity, even when that means showing people that I'm experiencing some trepidation or self-doubt in a given situation. I boost my sense of confidence by reminding myself that it matters how others perceive me and my abilities. If my CEO mom were here, I know she would be proud."

Sheri, a teacher described how she prepares in advance to avoid the Imposter effect. "One strategy I use to gain confidence is to rehearse possible questions or comments before presenting information at a meeting with my peers or supervisors. I talk out my main points in my car to work up the courage to get the message across without being nervous or anxious. I usually end up laughing at myself, which sometimes boosts my confidence. This also helps me think about potential arguments other people may have. If I'm prepared, I can avoid confrontation or conflict."

F*CK

POWER TIP

Keep your F bombs to yourself... or your best friend.

Watch any show on cable or for that matter network television and you can hear one of George Carlin's famous banned words. It seems the more profanity the greater the ratings. People in the workplace generally frown upon profanity because it's not natural to them. The exception in some instances, however, is for those who use profanity to build

strong bonds with coworkers or to develop team spirit and collegiality. In that sense, profanity serves as an unofficial bond between people.

As women with one strike against us already based on gender, we don't need another item on the table for discussion. Most people do not look favorably upon men or women who throw around the F-bomb. The sad thing is that there are two different standards operating; the one we see on television and the one that cages us at work, school, and in the community. Studies continue to suggest that women are held to a higher standard than men and that our culture is slow to change. If you are truly intent on gaining the power and influence you deserve notice how often you cut loose with &%##ll@ phrases at work. Your reputation depends on it!

And Now a Word from Your Sponsor

If you want to increase your influence and power it's essential to work with selected mentors and sponsors. Don't be afraid to take a chance and ask someone you trust to serve as your mentor. Most women remember the hurdles they jumped through to gain current jobs and remain successful, and many are enthusiastic about helping their colleagues. But again, you can't get help if you don't ask. Asking for help can be difficult but it ranks as one of the most important steps to take in your quest for attaining equal status in a male dominated world.

Finding a sponsor is another matter. Every woman needs a sponsor, a person to promote and speak well of them in public. A sponsor is the person in your corner who says things like, "Our new HR director is amazing; I worked with her on the last project and she gets things done." Another sponsor remark might sound like, "Jann is the best communicator for our foundation. It won't be long before she's our next director."

Sponsors are people who support your initiatives and promote your projects. They advocate on your behalf, often having the ability to

connect you to important players and jobs. In doing so, they make themselves look good. And precisely because sponsors take a risk with you, they expect you to be a star performer and extremely loyal. Sponsors know who you are and what you stand for because you take the time to apprise them of your latest projects and accomplishments. A sponsor is someone who will go to bat for you, and wouldn't necessarily be your friend, but rather someone you admire on a professional level.

Consider both men and women to tap as mentors and sponsors to help you grow, learn and thrive in your career and personal agendas.

Jolene confessed that if it weren't for one woman, she probably wouldn't be where she is today, an Associate Chancellor of a large university. "I was working in human resources and was very much resigned to the thought that HR was my ultimate career. Then one day the dean of the university came into my office and blurted out, *Why aren't you running this place yet?* I laughed at her suggestion, but she insisted she was dead serious about my leadership potential. This mentor and good friend spent the next five years encouraging me to apply for higher-level positions within the university. Her belief in me allowed me to harvest my own courage to do more with my life."

 POWER TIP

Don't be afraid to take a chance and ask someone you trust to serve as your mentor!

Excerpts from Ryder. Rules of the Game. (Delmar Publishing, 2016).

Mean Girls

Sand tiger sharks, spiders, hamsters and polar bears are a few animals known to 'eat their own'. Horrible thought isn't it? Read on. Women have their own dirty little secret.

When Felicia, a director of informational research and one of three women working in her organization was asked, "What do you like about the job?" her remarks were stinging.

"I love my job, I make great money, I've been able to climb the career ladder, and there's plenty of training opportunities. I feel confident I've made the right career move. The bad part about this job-my boss. She is a real bitch, par excellence."

Upon further probing she shared more. "She ambushes me in public. She doesn't do that to the men. From the smirks on their faces when they witness her attacks, I sense that they love it, which makes it even worse. I managed to get the courage to have a discussion with her and she countered with, *Get over it, this job is tough enough without you whining.* I stay away from her as much as possible but it's difficult since she's my boss."

And it's not just female bosses who cause trouble for women. It can be cousins, sisters, colleagues and even good friends. Sadly, we've been doing this for a very long time.

Women share that their journey competing for jobs traditionally held by men has been wrought with both internal (lack of confidence, courage) and external (stereotyping, child care, discrimination) barriers.

"Crashing through the glass ceiling was not easy," shared Linda, a newly appointed tech director of a large financial company. "I have the degree, I moved my home, I hired an interview consultant and I finally get this remarkable job. Then what happens? I collide with a woman boss who seems to resent I'm even in the

building. She's gives the impression she's jealous I've made it this far. What's up with that?"

The theory behind jealousy is intriguing. One theory proposes that jealousy evolved out of necessity. For example, throughout history people have battled starvation and have always competed for limited resources.

Myrna's story adds credence to this theory when talking about her place in the world growing up among six sisters. "We weren't hungry, but we all scrambled for our parents' attention and affection. That must explain why all six of us don't get along well on any given day. While we competed for our parents' love, sadly this ingrained sense of jealousy persists to this day."

Who wore it better, who's prettier, smarter, richer, slimmer? Women have been competing against women since birth. These built in stereotypes can be difficult to break through.

POWER TIP

Build strong and supportive female relationships!

An alarming study conducted by the Bullying Institute found that 58 percent of workplace bullies are women, and they bully other women 90% of the time. These women are often called 'Queen Bees', women who have a dominant position in a particular group and treat colleagues in a demoralizing manner.

Women who feel threatened by the success of other women often engage in indirect aggression toward other women who irritate them rather than addressing them directly. Regrettably, the most common reason women undermine other women is that they are jealous and lack confidence in their own abilities and self-esteem.

Queen Bees often feel they have worked hard to get where they are and that other women should work just as hard, thus the cold shoulder. Competition among women in the workplace is greater today. Women

know they have many challenges to overcome if they are to gain equity with their male counterparts, especially in top positions of leadership and authority. However, we all know women need to mentor and support other women, not detract from their efforts.

Remember, there is always safety in numbers. Find women allies who are coworkers, colleagues, and supervisors and build strong and supportive female relationships. Attend women's conferences, join or create women's networks, and keep reading about all the amazing women leaders taking center stage in our country.

If you are a woman reading this book take notice of your inner emotional state. Are you jealous of women around you? If so, examine the causes and begin to shape your narrative to one of support rather than provocation. Your reputation depends on it since once labeled the office 'Mean Girl' it's difficult to erase this dirty little secret perpetuated by your coworkers.

And women won't make it without you! Hold onto the confidence that behind every successful woman is another successful woman! The more women who gain seats of power and authority, the better the world will be for everyone.

Excerpts from Ryder & Briles. The SeXX Factor: Breaking the Unwritten Codes that Sabotage Personal and Professional Lives (New Horizon Press, 2003).

Fraidy Cat

If you want to build up your confidence here's a great tip that's often attributed to a quote from Eleanor Roosevelt, *Do something that scares you every day.*

After reading this quote on the internet one woman shared how she undertook a 30-Day challenge to do something each day that scared her. "I literally took this challenge to heart," boasted Mia, an advertising director. "Every day I pushed myself to do simple

things that required courage. One day I told a co-worker to stop hanging around my office sharing gossip. Another day I decided to wear a favorite outfit I thought might be too kooky for work. Each day I would think up something that took courage, like having a crucial conversation with a friend or something as simple as saying 'hi' to my cute neighbor. Some of these scary acts were silly but some were serious eventually causing me to face my internal fears about life. And you know what? Facing my fears mostly boiled down to doing stuff that helped me grow out of my comfort zone."

POWER TIP

Do something that scares you. Everyday!

One gains more courage by doing things we don't want to do. In other words, fear can be a real bully. Fear can tell you what to do and when to do it. Fear can gain power over us but when you face fear head on and do the opposite, you build courage. [10] It's such a liberating feeling!

I Wish I Were a 36 Double-D

Many women share that they get depressed scrolling through Instagram or Facebook because it seems as if everyone is enjoying life except them. They catch themselves wishing they could be happier, thinner, richer, or prettier. Well the good news is that comparisons are usually based more on opinion than fact. There will always be someone better than us and the sooner we recognize it the better.

Comparing yourself to others can drag you down and weaken your self-confidence. Successful women are aware of this power drain and have learned to recognize the triggers that spike these feelings of insecurity.

*Dawn, a successful business owner shared that she constantly com-*pared herself to other women and knew deep down these comparisons were making her feel inferior. "One thing I started doing was to become more self-aware when I was playing the comparison game. Social media was a killer for me especially during the holidays. It was difficult but I kept off Facebook during those times. Another time I was strolling through an upscale mall and started feeling I wasn't good enough, pretty enough, rich enough to go into some of the high-end stores, you know with the guard standing at the door. That's just plain silly. Self-awareness is vital if women are ever going to get ahead in life. We need to stop thinking we are not good enough."

Toni, an executive assistant shared she was feeling bad over being jealous of others more fortunate than her. "I had to remind myself that what people are showing on the outside is not always the true reality. For example, I've been jealous of a coworker for years. She seemed to have it all, the beautiful family, gorgeous husband and spectacular house overlooking the Pacific Ocean. I was shocked when I learned their kid was a drug addict, and her husband was having an affair while his business was going bankrupt. That was a real eye opener. I wasn't happy when I heard about their misfortune, but it made me aware that I shouldn't base my happiness on a comparison of someone else's life."

POWER TIP

Stop comparing yourself to others who appear to have a better life. Don't give away your power and energy.

And we all know that money doesn't increase one's happiness. But gratitude can. Many women share they commit to

being grateful for all the good things in their life to strengthen their confidence. Gratitude thinking helps them become less vulnerable to comparison envy. So, when someone or something gets in your face that triggers jealousy, stop and think about all that's good in your life right now.

And finally, if you've read anything about social comparison theory you know that sometimes comparing yourself to people you admire isn't all that bad. That's how we gain our identity, by comparing ourselves to others. So, if you wish you could be more like your boss who seems to have it all under control, full of charisma and oozing with personal power then ask yourself what you need to do to be more like her.

When Jen greeted her interviewer, she wished she had lost the bun. Who wore it tighter?

Finley
Age 30
Business Owner

This five-foot beauty catches your eye immediately with her red lipstick which is her signature beauty product. She packs the power with her smile and ability to make you feel like you are the most important person in the room. While young and still on the lookout for the love of her life, Finley is confident she does not need a man to make her happy. She has gone from being an employed haircutter, fresh out of beauty school to working as an independent businesswoman in one of the most high-profile shops in Newport Beach, California. She is a gem and indeed a role model for women wanting to take charge of their own lives.

Thank you for meeting today. Can you share anything that has contributed to your self-confidence?

Yes, I had parents that always lifted my brothers and me up. They would always tell us that we could do anything and praised us all the time. I would say when I turned 30, is when I felt the most confident. I always felt like I was a confident person, but for some reason something changed. I felt like my job was in the right place. I was happy with who I was, what I looked like, and what I was doing with my life. I don't know. I just think more women need to encourage other women. There's a lot of cattiness and things like that going on with girls growing up, even in your 20s and probably 30s. I always try to compliment other people because you know, when you receive a compliment it makes you feel more confident and so good.

Yes, compliments are important. Was there a time in your life when you did not have self-confidence?

I would probably say high school. I went to Catholic school from kindergarten to eighth grade. My first year in public school was ninth grade. It's just such a weird time in your life trying to figure out how to dress, who to fit in with, who you are and dealing with change. I was dealing with a lot of put down until I decided who cares what people think. Then, once I discovered that I didn't care anymore, things were better for me.

Is looking attractive a high priority?

Yes, it's a high priority because of my job. My mom was the type of woman who had her hair and makeup done, and would wear high heels, whenever she left the house. I was always around that while growing up. When I started my career my parents always made sure to tell me to dress to impress, look the part. After all, who's going to want to get their hair done by someone that doesn't have good hair? That always stuck with me. When I'm not at work I feel confident without having to do my hair and wear makeup. I think that comes with being a bit older. But it makes me feel good to look good. Trying to look your best really can help with building your self-confidence.

Do you do anything unique to enhance your personal appearance?

I recently just got my eyebrows micro bladed. I know it sounds silly, but now when I don't have makeup on, they look nice and natural. You know, we're all constantly filling in our eyebrows. The styles are changing and when I don't have makeup on I love my eyebrows. So that's one thing recently. And yes lipstick. I don't think you've ever seen me without it. I mean, I pretty much always have lipstick on. It's just something that's always been my signature thing. From 16 years old. Something I always loved. I wear red quite a bit, probably more than any other color.

Why?

I think it's just a cool factor for me. I don't know. I just always liked it. But again, referring to my mom, she always wore it. So, it was just a thing that I saw growing up. It came natural to me and I wanted to wear it.

Just saying, I love your red lipstick. What is the harshest criticism you've ever received?

With work, it's the hardest thing in the world when you do someone's hair. It's not always that you do a bad cut or color. But it could be a miscommunication on what we see or what we want. If they're not happy with it, it makes you feel like, oh my gosh, what did I do? Even though you know, you performed to the best of your ability. When I first started doing hair the hardest part was understanding that if a person doesn't like the results that it's not always your fault. Someone might ask you to cut a bob, but they weren't ready to cut their hair off. Then they don't feel confident about it. Or if they want to dye their hair black and they're blonde. It's just a big change and they've never seen themselves with it. So, just accepting that we did the best of our ability. You're not always going to have everyone love what you do.

What's the best advice you've ever received?

I don't know the exact quote or words, but it was something like the best situations always come from being uncomfortable. That really stuck with me. Anytime I felt uncomfortable with a job change or relationship or, just a situation in general, I will go straight forward and just go for it. It's always a successful outcome. So, I always liked that.

What's the greatest change you've ever made in your life and how did you manage that change?

The most recent one would be going from working somewhere for nine years as an employee and then taking the risk of becoming a

business owner. I was so scared, but it all worked out. I'm very proud of myself. And it's going just fine if not better than what I thought.

That must have taken a lot of bravery?

Yes it did. I think in that situation, I took the risk of speaking to people I looked up to. I gained confidence because they were rooting me on. Then I just went for it. Having that support really helped. The hardest part was finding financial support for my business. I was not going to fail, I'm not that kind of person. I come from a very competitive family. I knew I would work hard and do everything in my power for this to work out.

So, talk to me about when you envision yourself getting married, if at all.

When I was in my younger twenties, I imagined 30 being so much older and thought that I'd be married and have kids by then. But now I'm ready for a real serious relationship. It took a long time to accept when others were getting boyfriends or getting married or having kids. It takes confidence and knowing that there's someone out there for you. You don't need to rush the process. It's better not to force yourself into something that's not going to be good for you and wait for something that is.

Do you think you ever want children?

I do. I definitely want one. I thought that when I was younger coming from a big family that I would want more. But now with the kind of lifestyle I see myself living, I think one, possibly two. If I find the kind of partner that I could have children with and continue to be successful and financially stable I would start a family.

Would you ever have a child by yourself and raise it on your own?

Yes, for sure. That's something I thought about recently. Not right now, but in the next 10 years or so.

Are there any personal challenges that confront you right now?

Yes, quite a few, when my mom passed away. It's kind of an ongoing story and an odd story with what happened to her. My mother died unexpectedly. It's an unsolved murder case. With that said, the case is always open and impacts me every day. It's been nine years since her death. A lot has calmed down. I miss my mom and I think about her all the time, but I'm okay. So yes, I have a lot of challenges to deal with on a regular basis. I think about my mother every day, but I have gotten to a place where I don't think about what happened to her. I think about her.

That must be difficult. Was she a strong influence on your life?

Oh, absolutely. She was there for everything. She helped us all the time. She took us to school and helped us with homework. She was a confidence booster. One of the funniest things she would say to me was, "I thought that I was pretty, but you're a lot prettier than I am." She was always saying the funniest stuff to make us happy. She was a cheerleader and I'll never forget that. I'm lucky to have had her in my life. I had her until I was 21. You know, some people don't have moms at all, so I feel grateful for that.

She sounds like a wonderful friend and mother. What are your greatest fears right now? Do you worry about anything?

Well right now I'm trying to find a new roommate and that's always scary. That stresses me out, but I know it will all work out. But no, I have no big life fears right now, honestly. Actually. I have no idea how I remain so positive, but I do. I think I am as positive as I can be. I do worry about other people though. My fears are for other people, not necessarily myself, because I know I'll be okay.

You are in a field where you have both male and female supervisors. Can you talk about any experiences working with a female manager over a male manager?

I prefer to work with men over women. In my experience and I know not everyone has this experience, but men are a little more direct. They kind of leave you alone. They don't micromanage as much. I feel that a lot of women that I have worked with micromanage way too much. They are picky about little things, picky about you, kind of looking down on you more. But then again, I grew up with all brothers and I don't have sisters so maybe that's the difference for me. I work in a field that consists of primarily women, but we do have a lot of straight guys that work at the salon. I think that's why I liked this place a lot better than the one I was working at previously. There was a lot more cattiness, drama, unnecessary things, and trying to fit in with cliques. At my new salon that I am at now, it's not like that.

Where do you see yourself in 10 years?

I hope married in a successful relationship with a very loving man. I see myself being a good mom, but also balancing out work because work has always been very important to me whether it's part time or full time. And for me it would be building my clientele and being super busy at the salon all the time.

Has the #MeToo Movement had any impact on you?

I think being a woman in general, you get hit on whether it's at bars or work or wherever. I've never had a traumatizing experience. I've had bad relationships. I haven't had anything in my work environment or personal life that has affected me too much.

What are you doing to gain personal financial security?

I don't think much about that at this stage of my life, but I know I should. I've always managed my money pretty well, but as far as investments and things like that, it's not something I know a whole lot about. But people keep telling me I need to investigate that more.

How important are women friends in your life?

Very important. And I have a lot of them. I'm very fortunate to have a lot of very close girlfriends. I sometimes think that you don't choose your family, you're just born into it and there are times that your family can often disappoint you. But you can choose your friends. So, it's cool when you can relate to someone and have so much in common. Someone you can trust, push you, support you and boost up your confidence. Yes, I think that I am very lucky to have that in my life.

What do you do for fun?

Right now, I have a very extensive social life. I have totally over-committed myself to many things like going to lots of brunches or to the beach. I do a lot with girlfriends all the time. I'd like to do more athletic things. Right now, I am part of a boot camp that has helped with building my self-confidence. This group of female trainers and participants are so uplifting to be around. That's probably been the newest, coolest thing that I've done for fun lately. Going to the Boot Camp has helped me with so many things like reducing my stress, building my confidence, making friends, and getting more clients. It's a cool community.

You are a remarkable young woman. Do you have any final advice for women about gaining confidence, courage and power?

I think it's exactly what you just said right now. You gave me a compliment and that's the biggest confidence booster. I think more women should compliment each other. Like I was saying earlier, I think we all need that. We think she looks great, her hair looks great, but no one's telling her. You never know what someone's going through at the moment. It is so important to support other women in some way. Reaching out to friends and giving them encouragement is the perfect confidence builder.

Dare to Say No

Let's face it, women are expected to do it all and the word 'no' doesn't come easily. Men, on the other hand are expected to assert themselves and speak their minds, knowing that it gives them status and power. As women, we have been trained to be nice to everyone and make them happy.

Are you a woman who needs to set personal boundaries and learn to say "no" occasionally? Do people call you Superwoman at home, in your community and on the job? As females, we are often our own worst enemies. We multitask and take on almost any chore with a smile but in our hearts know that boundaries must be set if we are to maintain balance.

POWER TIP

Dare to say "No."
It's liberating.

If we say "yes" to everything it can be a disservice to everyone. Your mother wants you to fly across the country to help with her move into a new condo. You would like to ignore her request since you made other plans but feel pressured since she's always been there for you. Perhaps you live paycheck to paycheck and would like to turn down that hundredth offer to assume the role of 'professional bridesmaid'. You know if you accept the obligation to help your mother or overextend your credit card for yet another bridesmaid dress, you will experience some bitterness and resentment. And those feelings add up over time and that's called "stress". When we say "yes" to something we are not comfortable with, it creates tension in our lives and has an impact on our overall wellbeing.

Suggesting that a woman just say "no" is not that easy. It takes courage to give yourself permission to say "no" without guilt building up. Think about it. Is taking care of yourself such a bad thing if you are protecting yourself? Saying "no" may involve analyzing your daily routines and activities and taking note of where your time and energy is wasted. Are you committing to everything in sight?

For example, Kara, an attorney insisted she wants her child to be well rounded and give her a life she was not fortunate to have as a young girl. "I signed her up for everything under the sun; ballet, piano lessons, Girl Scouts, and two soccer leagues. The carpooling alone was killing me not to mention the number of recitals and games I had to attend. One day I took a hard look in the mirror and shouted, *Stop… I can't keep this up*. It turns out my daughter had the same feelings about being overcommitted. We took a pause in life and decided to regroup."

One additional aspect about learning to say "no" is that you may have more time to do something you really want. Think about learning to say 'no' the next time you get angry for attending a baby shower on a beautiful Saturday afternoon for a woman you barely know. Say "no" without the guilt and award yourself a gold star for taking care of YOU!

Stupid Girl

No one likes to look stupid. Many women share they are reluctant to take a chance on something for fear of looking stupid. This problem is difficult to address since the fear of looking stupid is deeply rooted in one's psychological arena.

There are major steps to take if you suffer from the fear of looking stupid. First, it's important to realize that everyone feels stupid at some point in their life. It all depends on where you are.

For example, Kristin admitted that she is a great public speaker if she doesn't know anyone in the crowd. "I freeze up when I am asked to speak in front of my colleagues. They know me really well and I want them to think the best of me so I'm really nervous when I know they could be judging what I am saying."

POWER TIP

Everyone feels stupid occasionally. Don't let it cripple you.

Anticipating or expecting too much, too soon, in any endeavor can lead to failure so it helps to be realistic with what you take on. But believing that you will fail almost guarantees failure. Studies of successful women reveal they accept failure as inevitable and are not afraid to take a chance. Next time you 'feel stupid' think about all the women you know who succeed at almost everything without being fearful. Be like them and resist the fear of feeling stupid.

Kristin's example of public speaking simply means that most of us fear looking stupid at some time in our lives. We all deal with insecurity and doubt. And remember if stupidity rears its ugly head, perhaps you are waiting in a lobby with ten other job applicants, know that you are not alone.

Home Sweet Home

A crippling fear that prevents people from embracing change is that of leaving one's comfort zone. Let's face it, change is difficult and staying put in familiar territory is less threatening. A school principal recently shared that it's pure hell when she must ask a teacher to move her classroom to another wing in the school. "I don't know what goes on in their heads. I would think the change would be invigorating but

most teachers plead to stay put in one classroom year after year. Funny thing is, once they make the change, they often say they love the new diversity in their life."

Andrea admitted that she took a chance on a guy she really liked but was afraid to make the leap because he lived in a foreign county. "I met this great guy on vacation and fell in love at first sight. It seemed like our relationship was meant to be until I found out that he lived in South America thousands of miles away from my home and friends. The idea of a long-distance relationship scared me, so I retreated into my timid self and called it off.

Upon returning home, my guts kept telling me this guy was the person I wanted to be with for the rest of my life. I took a chance, called him up and end of story- we are getting married in a few months. My fear of traveling back and forth to a foreign country and the potential of uprooting my life almost caused me to lose out."

 POWER TIP

In the end, do you want to be standing there with nothing accomplished because you feared taking a chance?

Michelle Obama shares, "Life is a journey to be embraced." How can we do that if we are afraid of life's challenges and fear leaving what we are most comfortable with? We only have one life to live. In the end, do you want to stand there with nothing accomplished, nothing gained because you feared taking a chance? I don't think so. Break out of your comfort zone, feel uncomfortable and enjoy the ride.

We started saving for our baby's future.
Alcohol and therapy don't come cheap.

Terms and Conditions

The workplace isn't perfect. Uncertainty still exists for how to handle issues of sexuality for men and women at work. And it's no secret that the #MeToo Movement has made life more difficult. One high level CEO disclosed that he was hesitant to hire a good-looking woman on his team for fear she would file a sexual harassment claim for something as simple as some guy saying he liked her dress.

POWER TIP

Report sexual harassment right away. The longer one waits, the more difficult it becomes to gain credibility.

Too many women divulge that they've experienced a sexual encounter at work and in retrospect wished they had reported the incident to human resources. One senior executive shared that she continues to have bad dreams from something that happened twenty years ago. "This guy grabbed me from behind at a holiday party and wouldn't let me go. He kissed me from behind and told me that I wanted it. I tried to pull away but couldn't because he was a big strong guy. Finally, he let me go when a coworker came around the corner. I have not forgotten his dirty attitude and trying to get away from him. But most of all I recall his nasty drunken smell. I was afraid to say something at the time but now wish I had."

A familiar excuse many women make involves fear- *I didn't want to make waves in the office.* Women should not be afraid to report sexual misconduct or intimidation from anyone. And reporting should be

done immediately. The longer one waits, the more difficult it becomes to gain credibility of the incident. The good news thanks to the #MeToo Movement is that the rules have changed. It's a whole new ballgame for women who no longer need to live or work in fear.

The A-List

Statistics reveal that over 140 million girls in the world are not in school. Without an education young women end up working low paying jobs, bear children at an early age, and depend upon their husbands or families for support. In other words, without an education a woman's future is limited.

POWER TIP

Become your best investment. Enroll in courses or learning activities.

The message is clear, educated women have better access to financial security and can actualize their hopes and dreams for the future. Studies report that if every girl completed 12 years of education, child marriage would drop by 64% and health complications from early pregnancy, like early births and child deaths, would drop by 59% and 49%, respectively. Educating women and girls also boosts countries' economies and lowers the risk of war and extremism.[11]

The women interviewed for this book were selected based on the perception that they regularly demonstrate self-confidence and courage. Each woman expressed the importance of furthering their education. Finley, age 30 admitted that participating in professional trainings in hair cutting and design increased her confidence to start her own business. Corinda asserted that her uncle's encouragement to apply for a sheet metal apprenticeship caused her to land a full-time union

job. An overwhelming majority of women emphasized that gaining an advanced degree in their field not only helped them become more effective in their personal lives but provided the essential skills necessary to compete for higher paid job promotions.

A university dean shared her amazing success story. "As a high school dropout, I decided I needed to do something, so I joined the Navy. My confidence grew through that experience, but I was keenly aware I needed to take my life in another direction once leaving the military. Mentors in my life encouraged me to take the next step to gain my GED and then enroll in a college program to earn a bachelor's degree. There was no stopping me after that. I felt so empowered with my new skill set that I went on to obtain a master's degree and then a doctorate. Not bad for a high school dropout, right?"

Asleep at the Wheel

Are there written rules that state women must work longer hours than men to appear qualified and competent? No, but often in a woman's mind there is. Many women work grueling hours and it's not uncommon to see 12-15-hour days. Why do we do this?

Becky, a financial manager shared that she gets stressed out if she's not working and finds her downtime completely wasteful. "All I think about is work. I have left all my hobbies and passions fall by the wayside, sacrificed to work. Honestly, I am afraid that if I can't keep this up, I will not make senior advisor in my company. I am tired and don't know how much longer I want to continue at this job. I know if I slack off, I won't move up."

Most women in their pursuit of power often stand to lose the very essence of what made them successful in the first place. Try not to confuse overworking with competence. Workaholics may win promo-

tions at first but can't endure the pace for long.

Ask yourself the question: *Do you really need to do all these projects or are you overcompensating for a lack of self-confidence?* And don't forget about the time you spend outside of work on household chores such as cooking and cleaning. Working mothers spend around three hours each day caring for their children while working fathers spend less than half an hour. Those pressures come at the expense of sleep and health. Even in the Year of the Woman, the average woman spends only 45 minutes each day exercising or relaxing while their male counterpart spends around four hours of downtime each day.

POWER TIP

You are just as competent as a man. Don't work 18-hour days to prove it.

Yayla has some great advice as a working mom. "I learned that contrary to public opinion and what one views on television that we can't have it all... the kids, the big job, the beautiful home, and amazing dinner parties. First, I have given up on the house. It's just not that important. Occasionally I will hire some house cleaners but if I have any free time, I spend it with my kids and husband over making sure my house is neat and tidy. For me, gaining a balance of what's important is critical. And giving up some of that power, knowing I can't be Superwoman is liberating. I feel in control knowing I'm doing the best I can."

Bragging Rights

Women don't boast well. Since girlhood, they've had it drilled into them that nice girls don't brag. Get over it-you need to brag. If you don't

brag, or for a better word, self-promote, others will take your accomplishments and claim them or worse yet, you will become invisible. However, know that there is a fine line between taking credit for the work you do and acknowledging it and outright boasting. The problem for women is that it's difficult to get noticed for accomplishments without being perceived as a braggart. And the research is clear that women get a bad rap when they are perceived as bragging. Men on the other hand are praised and flattered after boasting about one of their accomplishments.

POWER TIP

Learn the subtle skills of self-promotion and let people know your accomplishments.

Since it's the perception of competence rather than actual performance that often determines evaluations and promotions, women need to learn the subtle skills of self-promotion. Don't hide accomplishments that should be yours, but make sure you share your work without coming on too strong. Develop a personal brand that can speak for itself. For example, develop your power and influence on such a level that people learn to expect success from you.

> *Summer, a manufacturing executive, admitted self-promotion is a* fine balancing act. "We've been taught to say 'we' rather than 'I' when discussing projects we've worked on. I get it. That strategy works well for creating a collaborative culture at work but sucks for gaining recognition. I am very careful to point out that I was responsible for the success of a project when I have accomplished something on my own. It's difficult to say, *I did this... or I launched this project* but occasionally we need to let people know how accomplished we are."

Excerpts from Ryder & Briles. The SeXX Factor: Breaking the Unwritten Codes that Sabotage Personal and Professional Lives (New Horizon Press, 2003).

OHMIGOD

Married couples now share childrearing and household chores in the modern world. The bad news, however, is that women far exceed the number of hours devoted to these tasks. But men are more than willing to do their fair share in these relationships.

POWER TIP

Let your partner do their fair share no matter how dirty the tub is after it's been 'cleaned'.

The problem seems to be the quality of work. Have you ever seen a man clean a tub? To begin with he doesn't even think the tub is dirty. Then, once you have convinced him that this is a 'must do' chore, his level of cleanliness doesn't always come up to our standards. And then... who cleans up after the job is done? Who picks up the scrubber, cleanser, and paper towels? You guessed it. We do!

Much has been written and debated over this issue and some couples have even ended relationships over the amount of work being shared.

Sheryl Sandberg, author of "Lean In" nails it with the following assertion: "Women must be more empowered at work, men must be more empowered at home. I have seen so many women inadvertently discourage their husbands from doing their share by being too controlling or critical. Social scientists call this "maternal gatekeeping" which is a fancy term for "Ohmigod, that's not the way you do it! Just move aside and let me!"... Anyone who wants her mate to be a true partner must treat him as an equal-an equally capable partner. And if that's not reason enough, bear in mind that a study found that wives who engage in gatekeeping behaviors do five more hours of family work per week than wives who take a more collaborative approach." [12]

INTERVIEW

Beth

Age 30
Associate Director of Tech Company

B eth is a tall beautiful woman with a very strong sense of confidence. You immediately recognize her contentment by the poise she demonstrates in a room full of people. Beth has been a leader in whatever she chooses to delve into. She enjoys team sports and is a beautiful singer. She has diversified herself by traveling to over 35 different cities and countries. She has shown her courage by navigating an independent lifestyle very different from those women she grew up with. Beth has entered a career where she is largely outnumbered by males. I sense a lot of her statuesque and communication skills have developed over the past seven years because of her work environment. She is a strong young woman that knows what she wants in life. I sense Beth is on her way to achieving many lifelong goals.

Do you have suggestions for women on how they can grow their confidence to gain greater success in life and work?

Yes, women should not be afraid to speak up and ask for things. Start asking and telling your superiors at work what your goals are and what you want from an early stage in your career. As you continue to ask, you'll likely start seeing the benefits and gain confidence as your experience increases and you acquire new opportunities. I believe a woman should lay out her career and life goals both for the short and long-term view. For example, what are your one year and five-year goals and what can you do in the short term to achieve those goals?

That's good advice. What can you share about emotions in the workplace? Do you think women are too emotional in the workplace?

My advice is don't be afraid to show emotion but try to build up confidence and courage as time goes on. It's hard because our society, since we were born teaches and depicts women as sensitive and emotional, and something like crying is usually looked down upon in the workforce. But honestly, sometimes you just can't control it, especially if something happens to you that you don't deserve. Unfortunately, many men might see crying in the workplace as a weakness. If you can build up the strength from an early stage in your career and channel that energy into sticking up for yourself and staying strong, that will help.

Can you share how you feel about your personal appearance relative to how you live your life?

On the weekends I try to look nice when I go out because it makes me feel more confident and it's fun to get dressed up. I put on makeup and maybe straighten or curl my hair. But on the weekdays, I don't have enough time to get ready for work. I'd rather sleep than put makeup on. I don't wear makeup to work anymore unless I'm going to a client. Sometimes I put on makeup right before I go see a client, but I'll do it in the office. My priority is sleep during the work week.

Do you ever feel that you are taking on the entire world and there's no time for yourself?

No, because I always try to find time for myself. I did have a very busy period while in New York with my job. That's when I tried to take advantage of the weekends when I wasn't working. If I'm tired, I'm not going to go out. I'll sit and watch TV all day or do whatever I want. I take time for myself. I don't have that problem.

What's the best advice you ever received?

The best advice I ever received was to 'look up'. I've always remembered that from a speech from my college graduation. Someone who

gave the speech told us to always "look up". Everybody today is so consumed by their phones and social media. The speaker said you must remember to look up and see the world rather than being consumed by your computer and technology and what's in front of you. Look up to see your surroundings. I compare it to traveling. See the world. Try to see what's out there rather than constantly looking down and focusing on one thing.

What's the greatest change you have made in your life?

Moving to New York from Boston was a big change for me. But in retrospect I think that made moving to London easier for me two and a half years later. Moving between two continents was the biggest change. The hardest part was sorting out the admin stuff first. The first month you have a lot of admin stuff to go through like bank accounts and everything and you're so focused on that and then it hits you within the first month. But what I really had to do was let go of stuff that I was hanging on to back in the US. I had to look around me and see that it was such a good opportunity and not wasted because there were no strings attached. You know that you can always change your mind and go back to the US. You don't have to commit to anything. There's always an out. So, you live in the moment. You live and enjoy your surroundings and take advantage of the opportunity while you can and while you have it. That's what I did.

Have you ever felt left out of a social situation because you're not in a relationship and those around you were involved with a partner or married?

No, because I've always had a wide range of friends. I've never experienced that. I think being in large cities like New York and London, you're exposed to diversity of ages through work and depending on what extra activities you do. So, I've never had a problem where all my friends are married or have boyfriends because I have 23-year-old friends. But then I have 30-year-old friends. I also find that a lot of women are getting married later and later these days and there's not so

much pressure to get married by a certain age.

Is there anything about your future that worries you?

Yes, where I'm going to live. I've lived in three different cities. It's hard to know where I will settle down.

Some people call having grit, courage. Can you share a time in your life when you had grit to take on something people were trying to talk you out of doing?

Moving to London. My parents tried to talk me out of it. The greatest courage I've ever had to exhibit in my life was moving to London and living in New York City. I don't think many people could do that. I mean it takes courage to live in New York City. I think very few would even get the opportunity to move to London or even want to move to a different continent at the age of 27. That was the biggest thing that I've ever had to do. It took a lot of courage and effort to make that move. And there weren't many people who could help me with these transitions because, so few people do this sort of thing in their life.

Yes, not many young women take on the challenge of working in a different country. What are you currently doing for work and what steps did you take to get to this level?

I currently work at a tech company and I am an associate director. I used to manage a team but recently moved over to the relationship management team about four months ago. Before that I was in the Boston office with my company for about two and a half years and then New York for three years. Then I transferred to the London office two and a half years ago.

I started as an analyst and then just kept asking about how to move ahead in the company. I kept asking to go to New York. I worked hard and made sure I knew everything and understood everything about my job. As a result, I got an interview in New York sooner than everyone else. I think this was because I asked a lot. I finally got to go to New

York, and they paid for me to move which was great. Then in New York it was difficult because of the personalities in New York City that you deal with. Unfortunately, the personalities can be difficult because you're dealing with very sensitive situations involving money. It was a tough environment.

I got through this huge transition with my team of all men. They all became my good friends. I worked hard. It was such a challenging environment. I took advantage of the smart people around me to learn and ask a ton of questions. I wasn't afraid to ask questions.

Why do you think you moved so fast in your career?

The reason I got to where I am today in my career is because I kept asking my managers for more responsibility and I knew what I wanted early on in my career. As soon as I knew it, I voiced it and told my managers that this is what I'm aiming to do. I wasn't indecisive and I didn't change my mind on things. I was lucky enough in my career that I knew what I wanted to do. As soon as I knew, I told my managers and it got in their heads. So, as the opportunities came up, I was one of the first people that they thought of.

What motivates you to get out of bed in the morning? What inspires you?

Oh, that's an easy one, the future and possibilities. I also am motivated by my family, friends and my boyfriend. And I can't forget my interests and hobbies that make me excited every day. I love to sing, play field hockey, travel and of course don't forget TV. What inspires me? People who help other people, animals or the environment. I have so much love for people who volunteer—seeing videos online of people rescuing animals is a perfect example. If I was set financially for the rest of my life, I'd dedicate my working days to helping animals. Looking back, I wish I'd been a vet.

What do you care most about?

In my 20s, I was focused most on having a successful career, but now

it is my health and happiness. In my 20s I was extremely focused on my career and progressing to the next level with a higher salary. Now that I've reached a certain point, I'm content where I am, and I'd rather redirect my focus elsewhere. I've realized there are more important things to life than stressing about work, but then again, I am fortunate to be in a comfortable position financially. However, I want to continue to grow career-wise; I just do not stress about it as much. I've realized there are more important things to life than staring at a computer screen all day! You need to take care of yourself, your health and happiness so that you can live a long and fulfilling life.

Many women share that they wear something or have a favorite item that makes them feel confident. Do you have a signature item that serves as a symbol of strength or power for you and if so, can you explain?

If I wasn't 5'11" it would be high heels. I don't wear heals to work because they are uncomfortable, however being the same height or taller than a lot of men gives me subtle confidence. I'm so used to my height, but I truly think it is an advantage in the work place. I see many of my friends who are on the shorter side wearing high heels to every client visit. There is a lot of research out there showing that being tall helps in many ways in the work place and women have the luxury of adjusting their height every day at any time. And if heels are too uncomfortable, you can always bring an extra pair of shoes to slip into after important meetings. But for me, it's high heels.

In the professional arena, what do women need to do to gain equal access to jobs traditionally held by men?

It depends on the industry. Unfortunately, we may never compare to men in terms of physical strength, but we can always gain through our minds. For example, we might not see many women joining the construction industry and more specifically working on building sites doing heavy labor. However, if we are speaking more generically such as C-level, executive level positions, then there are a few things that

can be done – but I don't think it's the women who need to "do" the most to drive change. Rather the men need to adapt. Please keep in mind this perception is coming from someone who has worked in the financial-technology industry in both the United States and United Kingdom which is predominantly dominated by men.

Can you share specific career strategies you would recommend for women?

I believe it's important to promote and encourage career development for other women at their company or in the same industry. If possible, act as a mentor for other women and find a trustworthy and successful female mentor. Another thing is to network both internally and externally.

That's right, it's important to act as a mentor for other women in addition to finding our own mentors.

Yes, we should support women! We should always have each other's backs! I don't see this as much in my industry because there are so few women, but I have heard unfortunate stories through friends working in industries where the gender split is 50/50 such as marketing or PR. Many times, it is a female superior not having the backs of less experienced women or maybe even cases of bullying, and I always wonder why I hear this so much. I can't help but think why this is the case…but we should celebrate each other's success and qualities rather than feel threatened.

I also recommend not conforming to what men want you to be to fit in—be yourself and have your own opinions. A diverse group of people and opinions drives more success. I've seen many women over my career conform, especially when they are on a team of all men simply to fit in with the "bro-like" culture. However, this sets you as an equal whereas you could stand out in this environment. Being unique can be an advantage. If you're in a management position, work to diversify new-hire interview panels and encourage other women to aim for management.

Why do you think there are so few women in these top-level careers?

A large reason we don't see women in certain industries is due to the school systems promoting certain majors based on sex, or a historical trend people just continue to follow. I think the US is generally getting better at this as we see a lot more women becoming doctors and lawyers. However, we still need to improve on areas such as technology, finance, mathematics, etc. In the United Kingdom, it is clear women are encouraged from a young age to focus on subjects such as art, so we therefore see fewer females in tech and finance compared to the US. We need to promote from an early age all potential opportunities for women. For example, if you are a successful woman, an idea would be to speak at schools to discuss your career path and how you got there, or to participate in career days at your old school, that sort of thing. Also speak up and highlight gender diversity gaps to management and executives and propose ways on how to improve these such as creating diverse interview panels. Men just simply need to get with it…it's 2020! How many studies can there be that show more diverse environments attribute to great success. There is bias when it comes to promotions and hiring especially when it's an all-male panel, but this is where women come in!

What are you working on now to become a better person and take care of yourself?

Unfortunately, it's not a goal that I think about. In general, it comes naturally for me to be a good person. I mean it should be incorporated into your everyday life. Health wise, I'm trying to be more careful about how much alcohol I drink. That makes me healthy overall.

You work 24-7. What do you do in your free time?

There is a big drinking culture in London. A lot of my coworkers will go out for drinks after work on Thursdays and Fridays, but only until like seven or eight. And then on the weekends it's fun to get brunch with girlfriends, you know the bottomless brunches. I prefer day drink-

ing rather than going out anymore at night. I don't like to go out late at night too much anymore. I also play field hockey and I joined a field hockey club team, which is about half the year. They have socials where there's 12 men's teams and then 9 women's teams. So, you meet a lot of people through that. I also joined a gospel choir, which is about six months out of the year. I joined this club in London where you can go to events and meet people. It's nice to go out to dinner occasionally, but you must manage that so that you're not spending too much money.

What about travel?

Oh, yes, I travel a lot because I live in London, so it's something that's new to me right now. I think traveling has become a bigger thing for me in the past 10 years just because transportation has become easier, more accessible. And, in Europe the flights aren't as expensive. I didn't travel as much in the US because the airlines were so expensive whereas in Europe it's a lot cheaper to travel. I've been going to a lot of different countries, which has been great. It was something that I was exposed to when I was involved in a study abroad program in Copenhagen. I realized what else was out there in the world as I hadn't really traveled before. I realized how cool it was to see other cultures and experience their food and language. Even the party scene can be different in various countries. I'm fascinated by all the unique and different architecture when visiting these cultures. I also like nature traveling, like going to nice places in Sweden.

Thank you for your time this evening. I enjoyed all you had to say.

I have really enjoyed this interview, Thanks for including me in your book. I hope some of the things I mentioned can help other women.

Sharon realized that time wasn't on her side so she took things into her own hands and located a 'Ceiling Blaster' on Amazon. "Now I can crack this thing anytime I want."

What a Bitch!

Here's the scene. You are in a meeting and the guy next to you pounds the table over one of his passionate issues. You disagree and speak up, just as passionate and aggressive as your male coworker. The guy next to you rolls his eyes and says something like, *Simmer down, you don't need to be so aggressive.* Later in the hallway, someone whispers, *What a bitch!* Chances are you have lived this experience.

Gender studies are clear on this typical double standard. When females speak and act like their male colleagues they are shunned. This perception in the workplace has not changed for the past 100 years. The key for women, given this long-standing stereotype, is to know the difference between assertiveness or coming across as aggressive. What does that mean? How can you come off as assertive and not worry about being pushy or rude, or worse yet, the often-unavoidable insult of being called a 'bitch'? And you don't want to come off as being passive either. Thus, the conundrum for women in a male dominated society.

Alma, a school counselor asserted that it's important to recognize that gender differences exist. "It took me a while to acknowledge, not necessarily accept, the inherent gender inequities/disparity and power imbalance in society. The self-acknowledgement was liberating as it allowed me to embrace this reality and chart my course. I compete with passion and integrity, make sure my voice, which is respectful but firm and stems from my convictions is heard at the table."

Samantha shared her feelings about being called a bitch. "Once I started understanding more about the differences between men and women I could compete on my own terms and be assertive. I've heard that the men in the office think I'm a bitch when I make decisions. I don't take offense and know it comes from

their insecurity. I try to be who I am, a competent and successful woman."

What a great perspective! Both women are confident that learning to be assertive is a main strategy for competing in a man's world.

Assertiveness takes time to learn. Many women admit they have attended assertiveness trainings which is highly recommended if you're prone to flashes of anger over small things.

 POWER TIP

We are not 'bitches'. Assertiveness is a main strategy for competing in a man's world!

Jamie, a successful stockbroker talked about her overall success for competing in a man's world. "I believe that personal growth is non-negotiable. I have learned to be assertive by being prepared and learning to manage conflict. Assertiveness for me was one of the hardest skills to learn. I have attended several assertiveness trainings and listen to self-help books in the car on the way to work which has helped. It's all about getting the right tools in our toolbox."

If you suffer from a lack of assertiveness in your own toolbox, consider enrolling in some educational sessions or purchase one of the many self-help books on the market. Learning to be assertive is a critical skill for women. We need to be able to ask for what we want with deliberate intent while coming from a place of compassion. The power is ours.

The Unforgiven

Why do we continue to hold onto a grudge, when it can cause so much pain and hurt? According to WebMD, holding a grudge is bad for one's health and intensifies a feeling of physical pain even if the pain has nothing to do with the grudge. It also causes a rise in blood pressure, anxiety, insomnia, stomach ulcers and headaches. People who harbor grudges have higher stress levels and stronger negative emotions. There is also a higher chance of cardiovascular disease due to holding a grudge for long periods of time. [13]

So again, why is it so difficult to let go of a grudge and allow it to fester and take on a life of its own? The partner that has left us, the sister who said we are a horrible mother, the bully at work, the best friend who refuses to return a phone call. How do you move on and live the life you deserve?

POWER TIP

Give up the idea that the other person must apologize in a grudge. You control your emotions, not them.

It's not easy according to psychologists who have studied grudges and their impact on human relations. Grudges protect people from the hurt and vulnerability they feel. Hanging onto the hurt can be a power chip in a relationship even when the other person offers an apology. Since grudges have such a corrosive effect on one's emotional and physical health, learning to let go is critical and can be a long process.

First it is important to acknowledge that you have been hurt and to identify what happened and how it made you feel. The next step involves forgiving the person who hurt you. Forgiving is difficult but can be a wonderful gift to yourself as it frees you from the pain.

Forgiving doesn't mean accepting the behavior nor is it about winning. Acknowledge that there was a wrong doing, for you not them. You may not forget what has been done to you but by forgiving you will no longer harbor it in your psyche. Give up the idea that the other person must apologize and realize that you control your emotions, not them. Letting go of a grudge frees you up to focus on the more positive relationships in your life.

> *It's liberating, recalled Suki.* "I've been angry at my sister for twelve years over something stupid. We met at our father's funeral and I was more afraid of seeing her than the actual grieving for my father. We just looked at one another, gave hugs and smiled. We may not be the best of friends, but we're cordial to one another now. It was a relief to get this grudge off my plate."

> *Tonya recalled that her childhood with an abusive mother crippled her for years.* "She was a horrible mother which I don't want to go into. As a result of years of therapy and having positive people in my life, I was able to forgive this woman and move on with my life. I don't need to accept what she did to me, I just need to forgive and realize that she had not been a normal parent. I was tired of being the 'victim'. The pity party is over. I finally feel free."

Phone a Friend

Some women firmly believe they need to accomplish things on their own. They believe asking for help would reveal that they are a phony. Not sure if this applies to you? Ask yourself these questions: Do you always need to do things on your own, or have you ever thought, *I don't need anyone's help.* When making big decisions it's important to gain as much information as possible. Reaching out to others for advice or help is healthy and important for gaining confidence and success in life.

Women everywhere are failing to ask for help. We have filled our minds with such notions that we must have it all, push on no matter what and be strong in the face of adversity. We worry about homework, dinners, coworkers, losing weight, exercise, getting cancer; the list is endless.

And worse yet, some women advocates claim that asking for help is a sign of weakness. Camila, a senior auditor for a large accounting firm shared that she attended a workshop that inferred asking for help makes a woman look weak. "When I heard the speaker tell us this I winced. As a woman trying to do it all I know that I need to reach out for help. I don't think I'm weak. I think I'm smart. You have to be careful what advice you listen to out there."

POWER TIP

Asking for help is not a sign of weakness. It is a sign of confidence and power!

We are told we can do and have it all. Wise women know that asking for help is adding to their self-care. Vanya, a highly successful hospital administrator shared her story about reaching out. "I am not afraid to ask for help when I need it. I used to be too proud to tell people I suffer from depression. But that's over. I have some good friends who have helped me through some of the worst days in my life. I am an independent woman and have learned that I need to be mindful of my own limitations. I don't view asking for help as a weakness at all. I believe asking for help is all about self-awareness and wisdom."

In It to Win It

Have you charted out some hefty goals but don't know how to achieve them? Do you lack the confidence to do that one thing in life you've wanted to accomplish? Occasionally a lack of self-confidence is normal and even the most successful women experience it. The challenge however is to prevent a lack of confidence from letting you achieve the goals you have set for yourself. One of the best ways to boost your self-confidence is to know that confidence builds up over time with each success in life.

POWER TIP

When you feel you are losing self-confidence stop and count your successes in life.

The most important act to set yourself up for success is to ask, *What is it that I really want?* You can't gain success in life if you don't know what you're aiming toward. Once you have identified what you truly want then it's critical to determine if you have the knowledge, skills or ability to actualize that goal. For example, do you want to be an opera singer but can't carry a tune? Do you want to be an Olympic swimmer but have no innate athletic ability? Each one of us has been given certain physical and mental abilities and being realistic is important.

Once you have aligned your strengths and weakness with your proposed goals you must next develop a strategy to accomplish what you want to do. This may involve working with a coach or enrolling in educational or training opportunities.

And don't worry if you fail along the way. Failure is a vital component of a winning life. We have all heard the latest business cliché, *Fail Fast.* Don't be afraid to make mistakes. When making a mistake, ask

yourself how did things go wrong, what did you learn, and what will you do differently next time?

Finally, and most importantly, if your inner critic is telling you to take a step back, reflect on that negativity by thinking about your positive strengths. Don't give up. Set yourself up for a win.

What If My Dog Gets Loose?

Many psychologists believe that if you can change your thinking you can change your life. Wouldn't that be nice? Ever wonder how easy it is for negative thoughts to keep entering our minds? The big question is how to destroy these thoughts before they destroy your self-esteem and prevent you from maximizing your potential as a woman.

We are constantly surrounded by negativity in the news, on television, on social media and let's not forget the people in our daily lives. So how do you get rid of these pesky invasions on our brain before they take residence and become reality?

New York Times bestselling author and psychiatrist Dr. Daniel Amen has labeled these thoughts ANTS (automatic negative thoughts). Amen maintains that ANTS drive depression, stoke anxiety, and fuel negativity. And every time you have a thought, either positive or negative your brain releases a chemical. For example, when you have a sad, negative or unkind thought the chemicals released cause your body to feel awful. On the other hand, when you experience happy, loving, positive thoughts your brain releases different chemicals that cause you to be more relaxed, lower blood pressure and make your brain function better.[14]

Unfortunately, while many self-help books urge people to replace their negative thoughts with positive thoughts, the majority of psychologists report that method doesn't work. So, what does work? The first step is to become aware of the thought and try to figure out what is causing it.

Cara, a social worker said she suffered from insomnia for years, not able to fall asleep or worse yet wake up at two in the morning. "I couldn't stop these negative thoughts from ruminating around in my head. My presentation will be a disaster, what if my dog gets loose when I'm at work, why doesn't my boss like me? You name it, I always think of something bad to worry about. Interesting though, it doesn't happen much during the day, just when I'm ready for bed."

POWER TIP

The problem is not that we have negative thoughts. The problem is once we let these thoughts get a grip on us, we start believing they are true.

Acknowledging the thoughts and then challenging them is a productive method that works in most cases. For example, in the case of Cara's fear that her boss doesn't like her she could examine why she is thinking that way. She could confront the fear, in this case standing up to a 'boss' who she perceives doesn't like her. *Why don't you like me? I am one of the best employees in my department. Why even last week, you complimented me in front of the whole team.*

The problem is not that we have negative thoughts, they are perfectly normal. The problem is that we let these thoughts get a grip on us and end up believing they are true. Most people can push these thoughts out of their minds.

If you continue to experience negative thoughts and sense that they are crippling your life, it is important to seek professional help. For Ellen, a manufacturing designer, seeking help to confront her personal fears was a critical decision. "I have owned who I am and taken steps to position myself for what I want to accomplish in life. I have chosen to take control and not be a victim. I have had to deal with depression in my life and am tired of

negative thoughts taking over. I acknowledge this and manage it through medications I take every day. It does not define me but is merely a bump in the road. No one is perfect and everyone has their own challenges to overcome. It is the choice of the individual how to perceive and react to their own situation."

Good Vibrations

What if you learned that helping others, would contribute to a longer life of happiness? Yes, it's true. Scientists across the globe have proven that helping others and being nice to people can be good for us. In a society of competition where we must fight just to stay on top, helping others seems to be a miracle cure for what ails us. It gives us purpose and can contribute to a powerful sense of satisfaction.

Megan admitted that volunteering boosted her happiness and increased her sense of well-being. "I volunteer once a week at a VA center just talking with men and women who have nothing to do all day. Many suffer from PTSD and spending time with them is important. More important is how wonderful I feel after the visit. I don't always have the time to donate but I make time for it. The benefits to both parties, outweigh the time I give."

The research is clear. A team of sociologists tracked 2000 people over a five-year period and found that Americans who described themselves as "very happy" volunteered at least 5.8 hours per month. This heightened sense of well-being might be the byproduct of being more physically active as a result of volunteering, or because it makes us more socially active. Researchers also think that giving back might give individuals a mental boost by providing them with a neurochemical sense of reward.[15]

Mary, a retired school superintendent donates time helping women in her field to obtain jobs. "I used to charge for this service in my

consulting business but decided I would rather give this information away if it meant one more woman would become a school superintendent. Helping another woman gain access to a job that was incredibly difficult for me to obtain is exhilarating. She wins... I win. I feel as if I am involved in something bigger than myself and I love it."

POWER TIP

People who volunteer have increased confidence and better health!

So, the next time you think about wanting more friends, gaining more experience or doing something authentic that can increase your self-confidence, better your health and impact your sense of power, be kind and volunteer. Help a friend, donate to a worthy cause, or deliver an act of kindness to an unwitting participant. And watch your confidence grow!

Ticking Time Bomb

"I take care of my kids, my husband and my aging parents. Sometimes I wake up in the middle of the night and can't breathe. I know I need to start taking care of myself but can't find the time."

"I am overweight, have high blood pressure and drink too much wine at night. I feel as if I am in this vicious cycle of perpetual self-harm. I work 60 hours a week and my family would be out of luck if I was out of the picture. I need to do something and will soon."

If you are reading this book you obviously know how important it is to take care of your health and well-being. We are acutely aware of our role as mothers, wives, children, sisters, good friends, and employees. Self-care time can be difficult to find in our busy schedules but neglecting it will undoubtedly result in serious health challenges. The

result of not caring for oneself can wreak havoc on our health resulting in chronic stress which can weaken our immune system and make us more susceptible to disease, weight gain, insomnia, depression and heart disease.

Some of us react by tuning out. We binge TV or have a few extra glasses of wine at night disguised as self-care. Think, is this you? If so, get on Amazon right now and purchase a self-care book for women. After reading one of these books, select a few strategies to work on as soon as possible.

POWER TIP

Don't disguise bingeing on Ray Donovan with a few extra glasses of wine as self-care.

> *Nancy, a senior advisor for a marketing firm* disclosed that during her days as an executive she was burning the candle at both ends. "I was taking care of my family, two dogs, a sister with breast cancer and running a huge organization. One day I had this excruciating headache and being somewhat of a hypochondriac I went to urgent care during my lunch break. My blood pressure was 210/150. The physician said I was a ticking time bomb and sent me to the hospital for tests. I was prescribed heart medication and told to change my lifestyle. That day changed my life. I dodged a bullet which turned my life around for the better. During my last five years of work I ran a mile every day (I'm a bit neurotic), ate health food (no more sausage sandwiches for breakfast), worked out with weights for 30 minutes three times a week (in my office, too busy to go to the gym), cut down my alcohol intake drastically (save one glass of wine) and turned off the TV (except for Ray Donovan). They say women can do it all and I'm confident we can. But if we don't take care of the most important person in the equation, then we all lose."

Kat followed the address her online date sent and arrived at Costco. Shocked, she texted to confirm. He said, "I'll be right there, you'll love the tasting stations with unlimited servings."

INTERVIEW

Lisa

Age 40
Business Owner, Stay at Home Mom

Lisa is a confident, powerful female in every way. She is a beautiful African American woman with a stunning smile, radiant picture-perfect skin and pitch-black hair that makes you wish you could personally wear an Afro. Enough said, this woman is just plain remarkable. And smart, really smart! A retired military woman, she now serves in various roles to support her family in addition to working with female veterans. Lisa is a Dare to Say Yes woman. When asked to participate in this project she couldn't say 'Yes' fast enough. She is devoted to helping women succeed in a complicated society while raising her children to be the best image of herself on a good day.

You were selected to be interviewed because you are an extremely confident and courageous, young woman. What do you think has contributed to your self-confidence?

The number one thing that has helped me become self-confident was identifying and defining my core value set. I existed in a world where everything had been prescribed for me. Both of my parents were military. At one point my mom ended up getting out. My father remained in the military. It was a natural step to follow him. I felt comfortable in those worlds because everyone told me what to do. My mom became part of, for lack of a better term, a religious cult, which again, everything is prescribed for you. So, I looked around and at one point realized I had no idea who I was and what I wanted. I had to come up with my own core values. Once I did that, it laid the foundation for me to set

boundaries, healthy boundaries with people and be able to walk away from situations that were not healthy or enjoyable.

Can you share something you recently accomplished?

Right now, I'm excited about the journey and the person I have become. I'm excited about the pieces of the puzzle that are me that I put together. Without that foundation I could not be standing here having the confidence to launch a business or to do half the things I'd like to jump into. Because of my education, I have more confidence. So now I am a speaker at the California Women's Conference next month, which I'm really excited about.

That's a great conference. Good for you! What kind of strategies do you use to act confident when you don't feel confident?

I have to say… and that's often, that I chuckle when people tell me things like, Oh Lisa, you're amazing, you're this, you're that. I'm thinking I must really be putting on a great facade because that is not me all the time. What I've learned to embrace is what I call the word "flawsome". I am flawed, but I am still no less awesome. My flaws make me "flawsome". That's what I say. I've learned to accept that there are certain things about me and they are what they are. That doesn't make me a bad wife, a bad mother, or bad anything. It's the meaning that I assigned to it. And oftentimes when I start feeling less confident about something, it's because I idealized or romanticized this idea of what this situation, this project, should look like.

Can you give me an example?

One example I can think of immediately was when I had to go teach a course at the university and I was missing my son's baseball game. It was his first baseball game I ever missed. On my way to campus I was beating myself up. Like, oh my gosh, you're the worst mom. How dare you, you know this kid's going to hate you because you missed his game.

Mind you, he's six and has had 22 games. But in that moment, I was just hard on myself and I knew enough to say, Whoa, Whoa, Whoa, stop, stop, what's going on?

That's a wonderful story. I think a lot of women feel that way.

Yes, I started peeling back the layers and realized growing up in my household I was an eighties baby who watched a lot of TV. That was my escape because my home life was crazy. I grew up with these romanticized ideas of what an ideal mother is because my mother was not. I grew up with the Claire Huxtables of The Cosby Show and the Keatings of Family Ties and Maggie from Growing Pains. I was subscribing to this idea of what the perfect mother is. I just busted out laughing in the car and was like, you're putting all this pressure on you based on TV shows. He's going to be fine. It's one game. I don't even think that kid remembered I wasn't there. He was fine.

That's a good piece of information. I'm going to move on to the imposter syndrome, a belief that despite being successful, we're inadequate and incompetent. Have you ever experienced this?

Yes. I am lucky enough to be an alumnus of Leadership California, which is an amazing women's group. The first day I remember it being nerve wracking because you sit at this table and look around at everyone. Then I see everyone's name tag and I see one person is a director of education for Apple. One lady is the executive assistant to the CEO of Chevron. I mean, all these high-level women. I immediately became insecure. So, when everything got started, we were asked to go around and introduce ourselves at the table and share. I was last to go. As these women were talking, I started realizing, oh my gosh, they have the same insecurities I do. Even though they're accomplished, I mean very well accomplished, well on their way to C suite positions, when they got to me, I was able to talk to them and tell them to give themselves permission to be there. We all deserve to be at the table. We're all amazing in our own right. I went from being insecure in that situation to listening

to them and realizing we were all the same. I was actually able to offer a little insight into "It's okay, you're fine. Stop looking at each other's name tag and let's just get to know each other because we're all in this together."

So true. I'm going to move onto women's personal appearance. Is looking attractive a high priority for you?

No, I do not spend a lot of time on my personal appearance. It's kind of a little bit different maybe for me, I'm raising a daughter. I realized that I didn't want her growing up with that pressure. I'm very careful about how and when I put on makeup and the message that I'm sending her. We talk when I put on makeup. It's usually a special occasion when mommy just wants to try something new. What's interesting to me is when she was in school, she used to complain about her hair all the time. My daughter has gorgeous hair. I mean, it's ridiculous; people would pay for her hair. It was bothering me. I didn't realize she has super, beautiful, curly hair. Here I was straightening my hair as an African American woman because that's what we're taught.

Yes, I heard that you stopped straightening your hair.

I didn't realize the message I was sending my daughter. I was sending a message that her hair was wrong after everything else I did. That's the one thing she picked up on. So, I basically cut my hair off and decided to let it grow out in its natural state. I had not seen my natural hair since I was 11 and at this point, I'm about 35. Very scary. It was empowering to live, to step out into the world in my natural, what I call crown because for so long I had been doing something to manipulate my hair. That was part of the culture. It felt so awesome and free to wear my hair naturally. I love my hair now and I'm confident in it. I get more compliments too.

Why do you think growing out your natural hair as an African American woman would make you more confident?

I don't know why that one little thing would make me more confident, but it has. I used to be worried when I went into certain settings where people considered my hair professionally styled. I don't have that worry anymore because I think my hair is beautiful. I think I'm confident that more people seem to embrace my hair and compliment me. When it comes to beauty standards, hair is the number one thing in our house. The hair situation really started becoming an issue. We addressed it and I think we're more comfortable about it now. I even offered to straighten my daughter's hair one day for Halloween. She gave me a look that said, "Why would you ask to do that?"

Do you have a social media account and if so, what is your purpose for using it?

I was originally against using social media but then all my friends from high school wanted me on it. They would not tell me when and where the high school reunion was going to be. It was posted online, and they all said if you want to know, you've got to get an account. That's the only reason I got a Facebook account. Then it morphed into keeping up with friends and family and promoting my business, which is primarily done through Facebook. I have noticed however, that I had to put limitations on social media for myself because more and more negativity was creeping into my life through a screen. I'm a sensitive and creative person and social media was starting to weigh me down and I couldn't figure out why. I was feeling weird. Then my husband and I figured out the whole algorithms which are actually teasers. So, now I try to click on positive things and notice I get more positive stories in my life when I'm on social media. I'm very careful with social media. I see the warnings, while we consider ourselves connected, they are really superficial connections.

Let's talk about self-care. Do you ever feel like you're taking on the whole world with no time to even think?

Yes! Yes! Yes! I know that's one of the hot words right now, self-care. I try to get the women I coach to understand that self-care goes beyond going to get your nails done once a week. Sometimes you must go deeper than that. I recently took up the cello because I'm not good at self-care on a consistent basis. I'm not good at just doing something for me. I'm a natural nurturer. I figured if I signed up for weekly lessons and paid for them, I would have to take them. When I talk about self-care for myself, it must be something consistent. The other side of that is I've learned some hard lessons recently when it comes to self-care and my mental space.

Can you share more about that?

My parents, God bless them, I love them. For me as a veteran living with PTSD, my father is a trigger. I don't really like the word trigger so I call it a spark. He's a spark for me and I've had to finally tell myself, it is okay. You don't have to deal with him when you're not in the mental space to do so. It's okay to set boundaries. Sometimes my phone rings and I know it's my father. I will have other things going on in my life and won't be able to talk with him. I have given myself permission to be okay with that. Another example of self-care is when I say I'm not going to pick up your baggage right now because I can't. I'm dealing with my own stuff.

What's the harshest criticism you've ever received?

The harshest criticism I ever received was when someone said, "At least I act my color" and that hurt. It hurt because it was such a weird conundrum coming from another African American. Being an African American woman, especially one that's considered successful, you would expect your circle of friends and especially your family to be on your side. You would assume they would be on your side and sometimes it doesn't come across as they are. There are family members that I can get

into little verbal disagreements with and the first thing they will say is "Not everybody's as educated as you." What does that have to do with anything? It seemed almost the higher I climbed, the lonelier it became.

That's very interesting.

Yes, when I talked to a certain group of friends and I tell a story I must become a chameleon. I want to be accepted. I want them to like me. I want to be a part of the group and I want to laugh. But then when I tell that same story to a different set of people, I must adjust the lingo. I adjust my presentation. For a long time that bothered me. Then I finally realized I don't need to make excuses or need to explain who I am. These people weren't there for my whole journey. I am tired of listening to people who try to take me down. Your opinion does not matter. I learned how to stop taking that stuff in.

What advice would you give young women today about gaining self-confidence?

I would tell a younger person, you're fine. Stop comparing yourself to others. Decide what your vision is. How do you see yourself long-term? Then work backwards. Define the person you want to become. Don't let other people define you. What you will find is you will exist for years and then wonder why you're not happy. It will be because you're sub-scribing to other people's truth, not your own. Sometimes other people will not like your truth. That's their problem, not your problem. It is your job to like you, not everybody else's job to like you.

Great advice. How long have you been married, and can you share what you think the key is to a happy marriage?

Tim and I have been married for 17 years and a few days. I think the key was that we had an amazing foundation prior to getting married. We had that for almost seven years before we had our first child. Your marriage will change over time and everybody knows that. That's what you have to accept. The person I was when I married is not the person

I am right now. The biggest thing is communication and being honest with each other. He and I have this rule. When we need to say something to one another and we need the other person to hear what we are saying, we take the emotion out of it. We have a code word, which is "sidebar". We say, I need a sidebar right now because I need to say something and I'm not sure how you're going to take it. I don't want you to hear the emotion in it. I want you to hear the words. This works for us.

What an excellent strategy! Can you share a time in your life when you were courageous?

This would probably go back to the family piece. I had to have a crucial conversation with my dad because when he came to visit, I realized that he was a spark for me. He did something to set me off on a Wednesday. I remember going into autopilot. I remember a week and a half later I was at a stop light and that's when I came out of the fog from being in autopilot. I had lost a week and a half. I remember saying that's not good and I need to talk to somebody. I need to do something. I'm very honest and public about my mental health journey because I hope it helps someone. What I've recently learned is with that journey comes a commitment. I tell my husband, it's almost like when the doctor gives you medication. When you start to feel better you stop taking the medication. Then before you know it, everything creeps back in again. That's happened to me recently. I had to go back to therapy. I've made a commitment to go on a consistent basis even when I'm back to center and everything's good. I'm not going to think I don't need this anymore and quit going. I must keep doing the work.

You shared with me that you suffer from PTSD from your tour of duty in Iraq. What does that feel like?

I think it depends on the person. For me, it's one of those things that washes up on you and you're like, oh man, that was a bad week or that was a bad day. Then it recedes and life's good again. Life is good when I'm working on projects that I love and I'm passionate about. But when

those projects end, I'm like, oh man, what's going on? I start finding myself feeling those waves. For example, recently it was rejection. I applied for a teaching job at the local community college and I got a letter back that said I didn't meet the minimum qualifications. That rocked me. I don't know, maybe it was a little naive, but I didn't expect that seeing those words in black and white would really rock me. I had to pick myself up and after two weeks go see somebody.

That must be difficult.

Well I'm honest with my kids about it. I try to get them to understand their feelings and what they're going through is okay. It's OK to check in with yourself and say, Hmmmm, I think I need help. Asking for help doesn't make you weak. In the military world we're warriors and going to therapy in their mind makes you weak. That's not something you do in the African American community either. Black people don't go to therapy. What's wrong with you?

Thank you for sharing that.

Well I am just being honest about it and who I am. I'm okay with sharing this because if it saves somebody's life by reading this then you're a bit of my story and it was worth it. Most important it's nothing to be ashamed of. We really need to help the world get rid of the stigma because we know it exists.

Now for something fun. What's your favorite thing to do on a Friday night?

Friday night in our household is family movie and pizza night. I look forward to that because we all come back to center as a family. Usually every other night of the week is a mess with sports but Friday is that time where you're cuddling with everybody and laughing and watching something on TV. It's really nice to look down and think, this is my world. These are the little human beings I created. I don't know what they're going to do but I hope it's something amazing. I hope that I'm making this time magical for them and they're going to have great memories.

Have you ever experienced gender bias while competing in a man's world?

Having served in the military, which is a very masculine culture I did experience this a few times. I had a troop member who was a challenge. He kept me on my toes, and I had to hold him accountable. I remember one of my supervisors didn't agree with the way I was holding him accountable and he suggested that I should go home and talk to my husband about my decision. I told him my husband does not work in this shop and is not familiar with this issue. What are you trying to tell me? Go home to talk to him about it? For what reason? He looked at me but wouldn't answer the question. That was one of the times I was like, are you serious?

Anything else you can share about being a woman in the military?

Yes, in the military environment, a lot of us go along to get along and we talk just as awful as the men. We must prove ourselves. I remember being deployed on 9-11 and we ended up on fire teams patrolling the base. So here I am, one female in a Humvee with five men and I just felt like I had to go along.

Were there other women on this deployment?

Yes, and it was funny when we came back to our tents and took off all our protected gear, we were taking off more than just clothes. We were taking off that masculine shield that we must put on when we leave the tent every day. In that space we were just girls and we were trying to do anything girly, paint our nails, do our hair, do a facial. It was interesting to watch the dynamics when we were in the tent and when we were outside of the tent, the way we reacted. I would say looking back I wish I had sought out an ally. I wish that I had known that it was okay to not go along to get along, kind of thing. I didn't have to be like the guys but at the same time I understand why women do it. Give yourself permission to either say, I'm okay with this or I'm not.

Yes, good advice.

There were situations when I was uncomfortable, but I didn't have the courage to speak up. As I went up the ranks, I made sure those were the kinds of things I looked out for. If there were any female subordinates, I looked out for them. That's the other thing. If you are a woman and you're rising I don't know why some women feel they must think, "Well, I had to pay my dues so I'm going to make you pay your dues." Let's think about that. Why do we do that? Why do we see each other as competition?

You're walking right into my next question. Talk to me about how you personally advocate for women?

It's imperative that we help other women. Research shows that when women are at the helm, when we're in those positions, those key positions, we run flatter organization. That's huge. There is great success attributed to women being at the helm or at the table. That's number one. Number two deals with my organization working with women vets. That was one thing I really wanted to do because female veterans are in a special little conundrum. Some of them don't know how to negotiate salaries because everything was based on their rank. It didn't matter if you're a man or woman, you got paid the same based on rank. When they transition over to the civilian sector asking for something is difficult. Another thing I just read is that women talk about the disease to please. Well, in our world, when you're given an order you don't question it. When you're given a mission, you go accomplish it and you show your results. In the civilian sector, bosses are open to you saying, "Hey boss, I know we're trying to get from A to Z, but we really could bypass C and P and here's how we can do that."

I'm trying to help the female veterans learn that it's okay to speak up. I feel like I'm in my niche right now and working with some amazing groups. I'm finding that I am probably the only female veteran in the room. What I would like to do is set up a mentor program so young ladies going into the military would be paired with a mentor who's been

in for quite some time. If new women experience something weird, they can go to their mentor and ask, "Does this pass the sniff test? This felt weird. This was said, this happened. I don't know what to do. Am I reading too much into this?" They would now have someone they could bounce their stuff off. I am going to develop that program as I sure wish I had it when I was young in the military.

Thank you so much for sharing your story today. I can't wait to hear about this new mentor program.

I really enjoyed talking with you today. I hope some of this narrative can help other women.

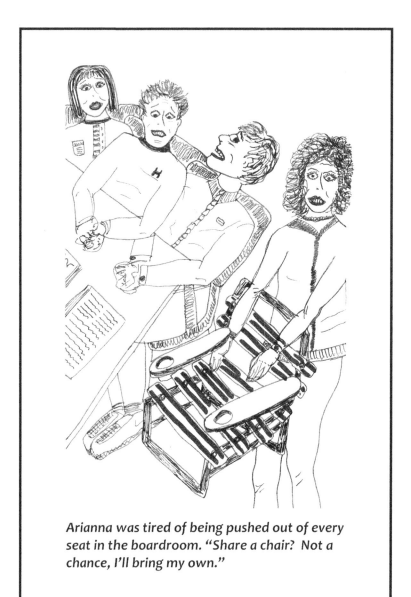

Arianna was tired of being pushed out of every seat in the boardroom. "Share a chair? Not a chance, I'll bring my own."

No Guts, No Story

Many women interviewed shared they suffered from a fear of rejection early in their careers often choosing not to go after something outside of their comfort zone. This fear is known to keep women from applying for jobs or positions of leadership that they could easily obtain. Many women feel that unless they are 100% qualified for a position they won't apply for a job while men with only 50% of the qualifications take a chance.

POWER TIP

*If you are afraid to upset the apple cart, you probably won't get that raise you want! *****PS Pick the Biggest Apple!!!*

Seo-jun, an account executive said she lost out on a super job opportunity in which she was very qualified and then botched the interview. "This loss was devastating, and I was beginning to think twice about placing myself back in the firing line. It took me a month to come to my senses and now I'm back in the saddle, putting myself out there."

Fear of being rejected also prevents women from asking for and receiving equal pay raises. Interestingly, the research on pay raises reveals that women ask for pay raises just as often as men however they are less likely to be successful as their male counterparts.

Judith, a director of a large tech company said she asked for a raise two months ago and was pleased everything went well. "I found out later," she complained, "that my male colleague in the same department asked for the same raise and got more than me. I am tired of this continual lack of equity in the workforce."

Ericka, on the other hand, acknowledged in her early years as a legal assistant that she was afraid to ask for a raise because she was concerned about upsetting her relationship with her boss. "I didn't want to upset the apple cart. Everything was going well; people were talking about promoting me and I didn't want my boss to think I wasn't grateful for my job. In retrospect I feel so stupid now that I know the younger women out there are getting the guts to be paid what they deserve. I read yesterday on the internet that one reason women are paid less than men, I think it's 83 cents to the dollar, is that for years women haven't asked for raises or if they do, they were unaware that the men were getting more. I have since asked for many raises in my life with success. Too little too late? I don't think so. I am really proud of these younger women who are standing up for themselves!"

And finally, Marilou, the first woman superintendent for a school district in Fresno, California shared that she was stunned upon learning she was the lowest paid superintendent in the county. "At first I didn't want to make waves since I had only been on the job for one year but I worked up the courage to ask the Board of Trustees for a raise. Their response was humbling; Come back in another year. One year later I went back to them with my request but also delivered a short lesson on how superintendents are paid. The more students in a district, the higher the salary, I asserted. I prepared a chart for their review detailing all county superintendents' salaries clearly showing I was the lowest paid while leading the third largest district in Fresno County. I was also the only woman on the chart! After reviewing my data the board granted me a 32% salary increase which made bold headlines the following day in the Fresno Bee. Note to self: I was really proud of myself for having the guts to ask for a raise and get what I deserved."

Give Me Your Best Shot

It's true, most women try to avoid any type of criticism. We often dodge feedback of our performance because we believe it will lead to doubting ourselves once again. We know that negative feedback can cut to our core and leave us feeling vulnerable. However, we have learned that feedback is necessary for success as it can correct small issues before they become serious problems.

POWER TIP

Ask for and embrace feedback. Then run with it.

In order to gain authentic feedback, it is important to ask for it on a regular basis and truly demonstrate you are open to accepting it. One of the best ways to do this is to take something small and immediately implement a change based on the feedback you have received.

A school superintendent once shared that she continually puts herself on the line with speeches, presentations, and professional development sessions. "While I work hard to perfect each activity, I always know there's room for improvement. One strategy for growth is quite simple and helps me move a project to a new level of excellence. After each presentation, I seek out a few participants in the crowd who look trustworthy. I ask ... *On a scale of 1-10 with 10 being the best, how would you rate my presentation today?* Usually the person pauses and then says something like *I'd give it a 7 or 8*. After thanking them for their response, I then ask, *What do you think I could have done to get this presentation to a 10?* You would be surprised at how many good suggestions I receive as a result of this simple spot check." Ask for feedback, embrace the feedback and take your performance to a new level of excellence!

Scout's Honor

When you purchase a product that claims to brighten your laundry, clean your floors spotless, or ease your pain, you expect the product to follow through on their promise, right? What happens when you discover your whitening detergent is a hoax, your floors look okay but have a dull residue on them or your head still throbs after taking that medication? You feel like you've been duped and will probably never buy that product again, right?

As a woman looking to gain power and influence what happens when you promise something and don't follow through? Same thing. People stop trusting you. The size of the promise makes no difference; if you promise to call someone at 4 p.m. and don't make the call until 4:15, you have not kept your word. And your word goes a long way when considering your reputation. If you promise employees that you will investigate the unsafe employee parking garage and do not follow through, people will learn not to trust you.

*Sheri, the manager of a large transpor-*tation company acknowledged that keeping her word is the most important thing that has contributed to her good name in the industry. "People know when I say I'll do something, I'll deliver. Most people don't think it's that important, but I know it is. I have a great reputation and men and women alike respect me."

Karin, a customer service agent offered another perspective. "Often, when confronted with angry constituents,

POWER TIP

If you tell someone you will call them back at 5:30, call them back at 5:30. Your word goes a long way!

we tend to skirt the problem by promising things we can't deliver. I've witnessed this scenario repeatedly throughout my career and work. I continue to inform our customer service agents to be aware of this. I advise all women who want to become more empowered and influential to be careful with your word, it is worth more than you think."

Excerpts from Ryder & Capellino. 92 Tips from the Trenches. (Delmar Publishing, 2014).

They Like Me, They Really Like Me

In a UCLA study subjects were asked to rate over 500 adjectives based on their perceived significance to likeability. The top-rated adjectives had nothing to do with being gregarious, intelligent, or attractive. Instead, the top adjectives were sincerity, authenticity, transparency, and capacity for understanding.[16]

POWER TIP

It's so easy to be likable. Put your cell phone away and make someone think they are the only person in the room.

Being likable is easier than you may think and it's important for building an overall positive image. Simple strategies to improve your likability include listening to others when they are speaking and being mindful of the conversation. Put away your cell phone and listen to someone when they talk to you. Look them in the eye and smile. Let the person know you are listening by nodding your head or asking questions. Also be genuine, give a hug, shake a hand, and try not to be the center of attention. It's so easy to be likable.

But of course, there are exceptions. Reflect on the following aphorism: *Fear is not a workplace motivator.* Many of us have worked for someone who was just plain mean. So mean that they took out all their insecurities and anger on their employees. If things go wrong for them, watch out. If you are reading this book, let's hope you are not one of those mean and angry people.

Treating employees with disrespect, calling them names, yelling or demeaning them at work is not high on the likability scale. In fact, employees in the modern age know they do not have to tolerate a bully boss and have learned how to file hostile work environment charges. If your anger is generated from insecurity, keep it to yourself. Work with a mentor or professional to discuss why you are angry and what you can do to overcome your insecurity.

> *Evelyn, a community college registrar discussed her experience* working with an angry boss. "A boss prone to angry outbursts is difficult to be around. I remember working for a director who would exhibit flashes of anger within a split second. People would come to my desk before going into her office and ask, *What kind of a mood is she in today?* No one wanted to say anything to her for fear she would explode. Within two years she was fired, and everyone cheered."

If you have anger issues, get them under control by seeking to determine their root causes. Work to understand the importance of anger management in the workplace and learn to express your emotions appropriately. If you don't manage this undesirable trait, don't expect to gain power or influence. If you are an angry person, is all lost? No, you can be effective if you're willing to practice anger management strategies and show concern for how your anger affects others.

Excerpts from Ryder & Capellino. 92 Tips from the Trenches. (Delmar Publishing, 2014).

Nothing But the Truth

If you're looking to increase your power and influence in your personal and professional life it's critical that you are known as an honest person. That means, don't lie, stretch the truth, or say "no" when you know the answer is "yes." However, sometimes telling the truth can be difficult.

POWER TIP

Telling the truth can be difficult. Be mindful of how much you exaggerate when making a point.

If someone asks you a question you clearly do not want to answer, there are ways to skirt the issue? For example, if someone asks, *Is it true that an employee brought a gun to work?"* You can always respond by saying, "I am not at liberty to answer this question right now as we are still investigating." If someone manages to get you in a corner, have an available escape hatch up your sleeve so you don't get caught in a lie. Avoid lying to decrease the probability of being known as a dishonest person. Use some of the following tactics when confronted with a question you don't want to answer:

+ **Respond to a question with a question.** If someone asks if there was a gun in the building, respond back with your own question with something like "How did you hear that? Tell me more?" Act professional and maintain an even tone to throw the focus back on the other person rather than you.

+ **Change the subject.** While this tactic is not always successful, it does provide the opportunity to move the subject of the conversation away from the original topic. For example, if someone asks

if you are mad at the new director you might interject with something like, "Did you happen to receive that email I sent to everyone last night about joining the new Art Foundation?" This immediate change in the original subject leaves people thinking you're not going to answer and may even make them forget what they were asking in the first place.

+ **Laugh it off**. This strategy can work effectively to derail an immediate response out of you. Laughing at a question asked or rolling your eyes upward saying, "Sure," or "Wouldn't you like to know?" always works when you don't want to divulge the truth or get caught in a lie.

+ **Act stupid**. Sounds like a stupid strategy but this works miracles. Such phrases as "Really? No way," or "How silly of them!" are great tactics to keep an incorrect answer from flying out of your mouth.

+ **Walk Away**. Finally, a preferred method, is to say that you have an important meeting you must attend, and that you will get back to them.

Martina, a branding consultant, reminds women there's a fine line between exaggeration and lying. "Don't confuse the two. Inflated stories are more a sign of a creative imagination than of a person who does not tell the truth but there is a small distinction between the two. Remember Brian Williams, the national newscaster who aggrandized his experiences during the Iraq war? Demoted. Be mindful of how much you exaggerate when making a point or being asked a targeted question."

Excerpts from Ryder & Capellino. 92 Tips from the Trenches. (Delmar Publishing, 2014).

When you think the whole world is having more fun than you on Instragram and you just want to curl up in a ball and eat comfort food.

INTERVIEW

Rose

Age 47
Vice President of a Community College

Rose is a small but mighty woman, extremely attractive with blonde hair and a beautiful smile. She's the type of person you nudge closer to be near in a room because of her infectious personality. She makes everyone around her feel happy and positive. Rose seems to have it all; wonderful husband, four darling and successful children, a high-power job and a beautiful home. One thing that stands out about this remarkable woman is her strength and resiliency. She is a dedicated feminist, recently speaking about women taking care of other women in the workplace.

Thank you for meeting with me today. You were selected to be interviewed for this book because you continue to demonstrate confidence, courage, and power as a woman. Can you share anything that has contributed to your self-confidence?

That's a loaded question. How far back do you want me to go? You know what I say, it starts with my mom. She always said anything a boy can do, girls can do better. Then she told me whatever you set your mind to, you can do. I'm little in nature. She always said, "Great things come in small packages." I think that anything I ever wanted to do; I could do. So, I have always had that mindset. I worked my whole life and believe that gave me the initiative to go do things, whether they're hard or not. I've also had great female role models which was good for building my self-confidence.

Can you share a time in your life when you did not have self-confidence?

I was in an abusive relationship when I was younger, and it rocked me to my core. I started looking down at myself because the person I was with would always question who I was looking at. You know, I wanted to date this other person, things of that nature and he would get mad. So, I would absolutely say that relationship put a damper on me in my early twenties for a couple of years.

How did you deal with it?

He was verbally abusive. He would put me down, that type of abuse. I stayed with him until he put his hands on me. That's when I needed the confidence to say, "Okay, now that you put your hands on me, I've got to go. That's not going to happen anymore." It was immediate. Then he was gone. I think that's when I decided to go back to school. I believe having a full education has helped me come out of a lot of that.

That's a good story for younger women to hear. Can you share how you feel about your personal appearance? For example, is looking beautiful a high priority for you?

I would say yes. I feel that in the industry I'm in, looks matter. I'm still into sports. I am physically active which not only helps my physical appearance, but also my mental state. When I'm not working out, I don't function as well. It's my stress reliever. I get up every morning and put on makeup. I think it's important for a woman to look her best.

What's the harshest criticism you have ever received?

I don't know if I can pinpoint anything specifically, but I have felt that I haven't been good enough before. There has been criticism throughout my life, but you just take it and keep moving in the direction you want to be in. You keep going in the direction that will enable you to be good enough and smart enough.

And what's the best advice you've ever received?

Probably that you can do anything you set your mind to. You just have to do it. I want to say though that you must remember it's not a straight line. There's going to be lots of stuff in the way and you must think how many times you can get up after being down.

You have four children. Can you talk about what it's like to be a working mother and the challenges you are confronted with?

The challenges of being a working mother or just a mother in general is that kids are hard. They don't come with a manual and every single one of them is different. You must figure out what their needs are. You feel guilt when they make wrong decisions. You know, having to pray that you raised them right. Hopefully they will remember their foundation. It's important to know that when they're adults, we don't get to choose their path anymore.

Do you fear anything?

Yes, I fear the death of my children before their time.

Yes, I fear that also. Some people call having courage, grit. Can you share a time in your life when you had grit to take on something that maybe people were trying to talk you out of doing?

Yes, here's a good example. A few years back during my work experience, I applied for a position that I thought I would be a good candidate for. I didn't get it. I was angry about it, so I created a position to get me a seat at the table anyway. It's a position that they're still using at other institutions. So, I guess that's kind of grit, right? If you don't want me sitting at the table then I'll build my own chair.

How about a situation where you think you've exhibited the most courage in your life?

When I had to put my son in a rehab facility. That story was hard because I told my son that I would not help him ever again until he was

ready to go to rehab. I learned my son was doing drugs and he showed up at the house. My husband was out of town, so I was by myself. We had just co-signed for his car. That day I ended up taking the keys away from him. He was coming down from the drugs and he was arguing with me. He said he wanted my help. I made the phone call to place him in rehab and planned to meet him at the house.

That must have been difficult.

Yes, I had already gotten him a seat at the facility, but I had 45 minutes to get him there. I think I spent 30 minutes arguing with him. Finally, I said, Okay, you've got three choices and I hope you choose the right one. You can get in the car and I take you anywhere you want to go, but don't ever call me again, ever. You can get in the car, I take you to Rehab. I pray to God that you choose this one because that's where you need to be, and get the help you need. Or three, I call the police and they come and remove you from the house. Those are your three options. Take them. He made the right choice. That situation was probably the hardest thing I've ever had to experience in my entire life.

How did you manage the courage to do that?

You know what? I don't think it was courage. It's not something that I thought of. It was in the moment of something that I needed to do to save my kid's life. I was on a timeline, right? I had a seat for him at this place and a certain amount of time to get him there. It was just what I had to do.

Thanks for sharing that.

I knew I had to live by those three choices too when I presented them to him. I'm just thankful that he chose the one I wanted him to choose.

Let's talk about your work. What steps did you take to get to this level in your career and how happy are you in your current job?

Oh, how happy? Careful what you wish for! I know that it's in my

personality to be in a leadership role. Education has played a part of it. In the doctoral program we've all been told that once you get your degree, doors will open. They swing open. People look at you when they never would've looked at you before. The networking that I've done in order to get in the position that I'm in now has really counted. I also think the fact that I have both private and public experience has helped in shaping how I approach my job and where my chancellor wants to go and where we are right now. Learning about people and knowing who you're working with is important.

Do you ever experience any differences working with a male versus a female manager?

I can't say that I've ever had a bad manager so I wouldn't say it was because they were male or female. I have been fortunate in that I've had some amazing female managers and leaders to work with. I like working with females. One of the topics that I am giving my presentation on is "Stop eating your own and start feeding your own". That's my topic for presenting to those working in law enforcement. I've never felt while working in the education system that I had to prove myself to a female.

For me, when working with males, and maybe it's just the age that we live in now, but I always feel like I must prove myself. I believe in team effort and all, but I've always said that working is not about the money. I never really negotiated a higher salary for myself. Now I know what I am worth and you're going to pay me for what I'm worth.

Has the #MeToo movement had any impact on you?

Absolutely. The one thing I will say that I never noticed before until I got this job is what they call, gender bias. In the private education institution, I never felt any gender bias. In this job I absolutely feel it 100%. I felt that within the first six months of my job. A male coworker said to me, "Did that just happen? Did we actually witness this?" I said, "We absolutely did!" I never experienced that before, until now. Just recently,

I don't want anybody to know this, maybe you should leave this part out, but I'm getting paid less than a man in my same position. I don't know how to deal with that piece yet. I've got to marinate on it. I know it's not going to sit well with me. I just don't know what I'm going to do about it yet.

That has also happened to me. Are you frustrated by it?

I can't even tell you how frustrated I am. I am going back and looking at some of the historic knowledge that I found out and learned that they paid an interim female less that they paid a male interim coming in right afterwards. I'm like, what the heck is going on here? I don't know if I'm going to keep my mouth shut, I just don't know how I'm going to deal with this because you know it's political.

Right. It is difficult and you are in a tough spot politically. I'm sure you will come to a good resolution on how to deal with that. Now onto something less frustrating. What is your favorite thing to do on a Friday night?

I'm exhausted after the work week. So typically, and I wouldn't say always but depending on if the kids are in sports or not my husband and I will meet for an early drink and, or dinner. Then we go home. I'm in bed early. I'm not a night owl.

Do you have any talents not associated with work?

Well, I just did a half Ironman.

Congratulations. Talk about that. Why did you do that?

Okay, so what's funny is that I remember when I was in the doctoral program, they made me write something about what my goals are and one of them was completing a marathon. So, I did the marathon two years ago at 45 years old. Then my husband who hates to run and I hate to swim, figured we would blend all of them together and start doing triathlons more seriously. I figured; well I want to be an Ironwoman so I decided to do the half first. My goal now is to do a full, just to check

the box and say I did it. You know, if you don't keep setting goals and moving forward, then I think you get stagnant. I'm never going to get stagnant. If it's not triathlons, then I know it will be something else I set for myself. That's just me.

What did it feel like when you completed the Ironman?

When I survived, I was extremely happy, but I will tell you it was also very humbling. Yes. Towards the end of the run it was 95 degrees and I walked most of the half marathon instead of running. It was a run walk. It was humbling, but I did it and I felt good setting out to do what I said I was going to do. Now next time I must beat my time.

How important are women friends in your life?

Extremely important. I have a group of women that are amazing in so many ways. We have each other's backs no matter what, but we also can have the hard conversations as well. Have you thought about it this way or, what about this? Having these women has been extremely valuable in my life.

Part of a woman's sphere of influence often translates to power at work and in life. What suggestions or advice can you share with young women today about gaining power and equal opportunity?

I think part of it is education. You've got to be educated in whatever you're doing, whether it's a formal or informal education. You've got to know what you're up against. I think trying is important too… I'm going to say this, "Don't settle!" Even though I'm in a position right now where I'm thinking, how do I do this and still be able to promote wanting equal pay, equal access because as I stated earlier, I'm in that position right now. Like I said, I'm still marinating on that. I don't know what I'm going to do with it. I couldn't keep my mouth shut because I'm on a trajectory for the presidency. Right? Spend three years where I'm at, okay, what I'm being paid and then go to the presidency. Then it's one of those things, okay, so I go to the presidency and they offer me a

lower amount. Am I going to accept that as part of my career trajectory? I am seriously having those conversations with myself even though I say to the younger generation, "Don't settle!"

Can you share any advice for women about self-confidence?

They must believe in themselves and when they don't, believe it anyways until it's true. There are many times when it's important to not listen to that internal dialog and continue moving forward with what you can do. We all have it. I have it. I mean you think I have confidence. But there are many times that it's like, okay, when am I going to be found out that maybe I don't belong here. But it's pitiful because I know I'm not the smartest person in the room, but as soon as I am, I know I'm in the wrong room. So, there's always that part of it too.

You have a very full life with your career and raising four children. How do you take care of yourself?

It's getting up at 4:30 in the morning and working out.

That's early. Do you go to a gym?

Yes, but it just depends on what activity I'm doing that day. I'll either go ride my bike in the morning or I'll get on the treadmill at my house or I'll go to the gym and jump in the pool. I typically do it four to five days a week.

That's amazing.

Well, I had to, I was training for an Ironman. I still got up at 4:30 this morning and got into the pool and went to the gym. It's my sanity. I'm telling you that I if I don't work out, I would be a bit snappy. I would be more emotional. Working out keeps me balanced. I have found that when I can't work out, I get moody. And I know one thing about me, if I don't do it in the morning, I won't do it in the evening. By the time I'm done with the day, I'm done with the day.

And what do you do when you get home at night?

Typically, I find out what the kids are doing. We all eat dinner. A lot of times I might answer work emails on my phone while the kids are watching TV and doing their thing. And I'm in bed between 8:00 and 8:30. I'm asleep by 9:00.

It's been fun talking with you. Do you have anything else you'd like to share with women about being courageous, confident and influential?

The biggest thing is not listening to the naysayers and getting up every time you get knocked down. I've been knocked down before even in the job that I'm in. I've taken swings and you just get back up. I'm determined to help students in my job now. I'm going to keep getting up until I feel that I don't have the purpose to do it anymore. I would tell other women to find your purpose, find what you think you can do to give back. Find out what you want to do and make it happen.

Erin gave her online date a pass for ordering hot cocoa during Happy Hour. He became miffed after learning the bar didn't stock marshmallows. Thinking positive, Erin thought, well at least this will make a great Bottomless Brunch story.

Love the One You're With

Are you living with a full heart, a heart filled with someone, some-thing, or others that you love and receive love from? If so, you are a very lucky woman. Cherish this fulfillment every day and keep it close. It's amazing how a bit of love can make a life that special. All parts of it!

For women who are not fortunate to have a heart filled with love and capable of giving love easily and unconditionally, life can be very bland and lifeless. On the other hand, yearning for love can be very unhealthy. It can cause anxiety, depression and constant negative thoughts. And this is especially true in environments that are important such as your social surroundings, workplace and community.

When you experience this emptiness take the time to re-evaluate your existing lifestyle. Examine activities that will enable you to engage with resources that will create a feeling of love in your life. Find people that share the same interests as you and join them. Remember having a passion such as a favorite sport or playing a musical instrument can fulfill some of that void in your heart. If you can afford or manage a pet think about taking on a lovable companion such as a dog, cat, goldfish or even a hamster. Oh yes and accept all the invites your friends extend to you. It may be the event where you meet that special someone.

POWER TIP

Don't wait for love to come to you, go out and find it! You may be surprised where it's found!

Lilly, a couture fashion designer, lived alone in New York and felt sorry for herself as she watched everyone around her share stories of love and affection about their partners, families, pets, hobbies, sports and talents. She decided that being lonely and

having nothing to love or be passionate about was her own fault. She'd fallen into a routine and hadn't realized that time was rolling along with the "same ol' same ol'" days ahead. She set out after work one day to visit the local humane society. While visiting she was asked to volunteer and dog walk some of their tenants. After two weeks Lilly became so attached to Sibel, a homeless hound dog, that she became a foster parent and then ultimately Sibel's owner.

Growing up with sports and playing sports throughout college, Melanie, a nurse practitioner suddenly found herself not playing her passion of basketball. She realized several years had passed without playing on a team and experiencing the fulfillment and love of the sport. She set out to find a league that would work with her schedule and challenge her skill level. She found a league that met once a week after work and on Saturday mornings twice a month. "Once I got into the league and played again, I was able to kick in the endorphins. I loved every minute playing." The best part she shared was making all sorts of new friends, one of which is Oliver, who she is now dating on a regular basis.

It's not easy to admit you lack a full heart but you can start to fulfill it today. It does require effort and a little research, but you just might find yourself loving the one you're with!

I Just Ate a Hotdog

Do you post a lot on Facebook or LinkedIn? If you are accustomed to posting job successes or family photos or your latest and greatest accomplishments, consider turning your posts into valuable messages. That is, try to contribute to the discussion.

Shelby, a search consultant with a tech firm shared that she has over 500+ Facebook 'friends' and enjoys spending time reading the latest newsfeed posts. "One day a particular post caught my eye. The post was from a colleague who posted a quick review from his perspective on a play he'd seen. I began to seek out his posts. Rather than post where he's been or seen, each post sounded like a personal blog. Mohammed Ali passed away and he wrote about his experiences knowing Mohammed and shared some personal Ali memorabilia. I look forward to his posts because quite frankly he contributes *to the discussion.* While I may not agree with some of his opinions, they certainly get me thinking how I could better manage what I post on social media."

Next time you post something on Facebook or LinkedIn, think about enhancing your presence by posting a meaningful reflection. As a result, you will have people thinking about what you have to say in addition to noticing you in a professional manner; a lot different than sharing what you had for lunch at the latest hotdog stand.

 POWER TIP

Become a thought leader.

And don't forget real life settings. When sitting at a table or in a group try not to let others dominate the discussion (yourself included) and don't sit back and let others do all the contributing. Be bold, reflect, make comments, offer ideas, opinions, and share your power and influence.

Forever Amiga

Women who understand the importance of community and personal power know that building a network of people committed to their

personal and professional growth is critical for success. Women need to build a cadre of people who can support their goals, listen, give opinions, and help to guide them through difficult decisions.

When we know we are not alone, we begin to shape a sense of solidarity rather than isolation. This is especially true when having a group of close nit women friends. Stacey, a retired military leader asserted that she would not have been able to survive working in a male dominated arena without what she liked to call her 'Best Buds'. "My woman friends are everything to me. I am who I am today, because of them and their support. We give each other advice, lend shoulders to cry on, keep secrets, and boost one another's self-esteem."

POWER TIP

Make a lot of women friends. When women know they are not alone, they begin to shape a sense of solidarity rather than isolation.

The psychology behind strong female friendships is powerful. A study published in the *Journal of Clinical Oncology*, revealed that women with early-stage breast cancer were four times more likely to die from cancer if they didn't have very many friends. Those with a larger group of friends with early-stage breast cancer had a much better survival rate. An article published on the *New York Times* website states that women feel they can count on their friends to pull through for them no matter what they are struggling within their lives.[17]

What are you waiting for? Make a woman friend today. Friends are better than money in the bank!

Fan Club

Austin Kleon in, *Steal Like an Artist*, maintains that "You're only going to be as good as the people you surround yourself with." Kleon shares Harold Ramos' the actor and director in the movie Ghostbusters secret for success: "Find the most talented person in the room, and if it's not you, go stand next to him. Hang out with him. Try to be helpful." Ramos was lucky: The most talented person in the room was his friend Bill Murray.[18]

This same advice applies to your everyday thinking when developing your personal power quotient. Hang out with people you admire, watch them and ask yourself what makes them special, how do they talk to people, what are their skills and attitudes? Obviously if you admire these people, they have a positive brand.

POWER TIP

Hang out with people you admire and ask yourself what makes them so special.

Rachel, a superintendent of a large school district talked about her experience working with her boss, a highly successful women superintendent. "I was an assistant superintendent at the time and I admired how she worked so well with the school board, the principals and teachers. She was extremely well respected throughout the county. So, what did I do? I watched her and tried to emulate some of her behaviors and work styles. I learned a lot working with her and attribute much of my success today to her."

And by the way, Kleon advises that if you find yourself the most talented person in the room, find another room.

INTERVIEW

Morgan

Age 52
Director of a Chemical Lab Corporation

Morgan is a unique woman, a STEM woman. She's a chemist. Who knows a chemist? We do and are so pleased she gave us time to share her story. She has a logical but friendly demeanor, scanning the environment wherever she goes. She exudes confidence especially when ordering a bottle of wine or sushi. Morgan is a strong woman, one that many of us would love to emulate. She has an infectious smile, an engaging personality and exhibits courage extraordinaire. She is the kind of woman you would want to be with in an emergency or life-threatening situation. Somehow, you know she would make it all better.

You're a very confident woman. Can you share anything that has contributed to your enhanced self-confidence?

The greatest influence on my life was how I was raised as a child. One of the expectations that was required of us when growing up was that we try everything. It started with food, even if we didn't like the looks of it, we at least had to try something once. I think from that kind of broad expectation I was able to experience different things. I discovered things I really liked and was encouraged to try them once I made a sound decision. If you try it and like it then go for it. I had a good backing from that perspective while growing up as a little kid.

Did that experience carry over into your life as an adult?

Absolutely. Throughout my academic life I found subject matter that I really felt strongly about and excelled in. I got the support I needed from the educators all the way from kindergarten through my college

years. I was very blessed to have excellent teachers and educators that helped build my self-esteem and support that growth.

Has there ever been a time in your life when you thought you didn't have self-confidence?

Well, this is a tough one. It's emotional. It's when my mom was dying. Nobody else in my family came around, they all became ostriches with their heads in the sand. It was like the situation didn't exist. I was thrust into a lead role where I didn't know what to do. I didn't know how to manage any of the situation.

How did you handle all of this?

I didn't know if I was doing the right things. You're kind of testing the boundaries of what to do and what you think this person's wishes are. Asking yourself if you are doing the right thing in the end. I think yes, I did but only because of the conversations I had with my mother. It was very difficult during those last two weeks of her life. I hand to handle things I was not familiar with in the medical arena. Like when she was going into a coma and the medications and life support they had her on. There was no documentation, only conversations we had. That's a lot to put on someone's shoulder. You know if you pull the plug, your mom's going to die and you're the one that made the decision. I had a lack of confidence then. But in the end, trusting those conversations that I had with my mother and trying to remember them appropriately in my head was how I managed. We had a lot of those conversations. I think that helped me get through that process.

That must have been a difficult period in your life, and it sounds as if you gained confidence while handling the situation. Now onto a question about personal confidence. Can you share how you feel about your personal appearance relative to how you live your life?

Well, define looking good, right? I don't concentrate much on my personal appearance because you are talking to someone who used to

play a ton of sports. I was involved in bodybuilding for many years in college. To me, how I feel about myself, not necessarily how I look in a mirror is important. If I feel I look good, then I look good. Am I where I want to be physically? No. There are many excuses. But I feel good about myself. I understand from a mental and emotional perspective, I have a very sound base. I have strength and confidence which allows me to present myself in an attractive way. When you feel confident you feel attractive. I don't ever want to look scrappy. No matter what I'm wearing or how I'm dressed, the way I present myself as confident is more important.

Do you have a social media account and if so, what do you use it for?

Oh, that's a good one. So, I have resisted social media. I'm one of those people who is private, more private than a lot of others. I'm more introverted than extroverted. I don't need people to give me my sense of self-worth, which I think a lot of people in social media do. Either that or they're really conceited. I had a Facebook account. I started it in 2010 and honest to gosh this question is crazy because I just deleted the account this weekend. I didn't feel there was a purpose in using social media. It's important for me to communicate with people by picking up a phone or speaking with them face to face. I get more out of those interactions than I ever would out of just blurting something out on social media. Social media serves a purpose for a lot of people, but for me right now it does not.

Your take on social media seems to be a theme with a lot of women. On another subject, what's the harshest criticism you've ever received and how did you respond?

Wow. Now that I think about it, it goes back to me playing what we call travel ball. I was playing softball and just starting out. I was a confident, little cocky person. I think I was probably 19 or 20. I was playing on a travel ball team and we were going to the women's nationals. They were cutting the team down to just 16 members from the 20

that we were carrying. I got a phone call from one of the coaches, and not even the top coach. He basically said, "We're not taking you with us to Goshen, Indiana." That's where the women's nationals were that year. He said, "We don't like the way you play the outfield."

That must have been devastating.

Yes, it was. There'd been no coaching, no anything from them and no discussion about this at all. It was just this phone call. When I questioned him about it, all he could tell me was that they didn't trust my judgment on the field. I was, wow, I made the college team and everything. I don't know what you're talking about. I think it had to do, quite honestly, with my sexuality. They handled it with real brute force and no explanation. They couldn't give me any specific about what I was doing wrong. I remember that knocked me back quite a bit. It really called my confidence into question. I loved playing ball. No, I wasn't the best out there, but I loved playing ball. It was my social life. It was my exercise. Playing ball made me feel good. That experience was just very odd. I remember I literally didn't play for two weeks after that. It called into question everything I was doing with the sport. I finally sat down and asked myself why I was playing ball. I thought about the other teams I was involved in and their positive responses. Honestly, out of the whole thing, it taught me to ask questions. I should have asked more questions and I do that today.

You sensed they cut you from the team based on your sexuality. Do you think it had anything to do with you being gay?

Absolutely. I think that's why they decided to cut me from the team. There were only two gay people on the team and neither of us were selected to go to nationals. I truly believe this was one of the first biases and examples that I went through regarding a judgment about my work based on sexuality. I don't look much different now than I did back then. It's wasn't a secret.

So, obviously it impacted your life?

Yes, a little bit. I'm really an introvert. I like my quiet time and things like that. It made me question for a long time how I presented myself to them and people in the world. When I was in college, I was very "out". I was doing political rallies, a lot of that stuff because I was in it. It was in the early eighties and the 25th anniversary of Stonewall. All that stuff was coming out. We were hyper political and in college at that time. It wasn't an unknown fact that I was gay, but it made me step back a little bit from some of those things that I was involved in. It really did.

What advice would you give young women today for gaining self-confidence?

I would try to locate a great mentor and not be afraid to ask questions. I think that's critical. Your worth is no higher or lower than anybody else's. Your need to obtain an answer or guidance is no stronger or weaker than anybody else's. I was blessed with my education and my family growing up. I think you've got to be able to communicate with someone you trust. Someone you believe in will guide you through your journey.

That's great advice. On another subject what do you fear, if anything?

Sometimes if I fail at something, I fear I am letting people down. Especially people that I love. There's been times in my life where I've gotten a little overwhelmed and I feel like I can't do it all. If I let someone down, I become an introvert and stop communicating. I fear that if I become overwhelmed and self-encased, I won't be present for others who may need me.

Can you recall a time in your life when you were in trouble with something, let's say at work or with a friend? What was your strategy for dealing with the problem?

One of my friends was in a relationship. I knew that their partner was cheating on them. I realized that if I'm going to be a good friend

then I should be direct with them. I approached this friend and delivered the information. It was up to them to do with it what they wanted. This was scary because you worry about losing the friendship and about hurting the person. I also worried about them calling me a liar and other things. For me, it was being able to set up a meeting with this person, sit down and tell them what I knew. Having the courage to have the conversation was a challenge.

Did it work out?

In the end? Yes. There was some resistance at first because I think when people are blind to certain things, they're blind to everything. I mean they are either in it for the wrong reasons, so they choose not to see things. They just can't get out of what they are involved in or they truly don't know what's going on. In this case, the person wanted badly to be in the relationship but didn't want to hear it. About six months later the person came around and finally realized it was for real and understood what I was attempting to do by coming forward. I was called a few, colorful words bringing this forward but in the end it all worked out. We're still friends.

That's a good story. Have you ever been in a situation when you've given your opinion or delivered constructive criticism and not been received positively because of your gender?

I'm not one to normally give my opinion unless it's asked for. However, when I was at my very first job in this field, I held a position equivalent to another man. He and I had the same responsibilities. I walked into the office and asked for a raise. I was told by the owner that I wasn't going to get a raise. He told me there was no way in hell he was going to pay me what he was paying his Ph.D. because he has a family.

That's amazing.

That was my first experience with not really voicing an opinion. After trying to state my case I basically was told you're a woman, so shut up.

You are quite far along in your field. Does that ever happen to you?

I don't feel that my word would ever be called into question by anybody, quite honestly, male or female. I feel very free to converse within my industry. I'm asked to speak in my industry quite often. I have been called into court as an expert witness. My standing and what I do at the lab, carries over into other things that I do in life. I have gained confidence from my experience.

Do you ever experience prejudice being gay?

Oh, yes. There are people out there all the time. You can get a sense of it. Sometimes when I'm out in public I will hear snotty little comments. You just become used to it. I hate to say you become used to it, not numb, but used to where you let it go. You think to yourself, I'm sorry this person's not worth looking down upon. They are just another ignorant man and I move along.

That's a good way to look at it.

You do worry now more in society. Maybe just because I'm a little older I worry about the hate. I worry about the reactions from people regarding LGBT issues. As you know our political system has become more divisive. Sometimes I worry about being in public and where I'm at. You pay attention to the crowd that's around you. You're always looking for an exit. You're always looking for things just from a safety perspective. But in general, I don't feel that way. That's not my sense of purpose in life where I think, everywhere I go, somebody's going to try to get me.

Thank you for sharing that. What are you currently doing for work and what steps did you take to get to this level?

I'm a laboratory director. I run an environmental lab and a service center located in another state. What did I do to get to this level? I started at the bottom. I learned everything I could about the position. I was mentored by people I felt could help me grow in the industry. I

reached out educationally to gain a master's in business and then a doctorate in leadership. My degrees helped me to understand the business side, the people side and the industry itself.

Let's talk about influence. Whether it's small scale or large scale, how do you influence others?

I've always had a continuous improvement process mindset where I'm always looking to do something better or prove something. To get people on board with that mindset I learned that number one is to communicate, communicate, communicate. What is the vision? Where are we trying to go? Who wants to help me? Who can give me feedback? I reach out to those I know can help. They're not eager right out of the gate but once you talk with them you can start drawing them into the circle. I ask and welcome their feedback. I've found it to be successful for me at work when the lines of communication are flowing.

Why do you think there's more men in your industry? And at what point do you think it'll be equal for women in the science fields?

There are more men in the science field just as engineering because that's how a lot of us have grown up. This next generation of girls may have a better shot at getting into the science fields; a 50 50 thing. We're getting close to that in this industry. You're looking at probably another 20, 25, 30 years maybe where women will be equal in the science fields. Science and tech are still not being pushed all the way down to the grade school levels. School systems are trying to emphasize the sciences and technology fields more and more. But it's going to take time for women to gain equity in this field. I do believe that a girl's brain probably functions quicker at a younger age than the boys from a mindset of math and language.

You are so on target. Girls score higher in math and language in elementary school than males but then take a slight dive in junior high.

I'm no expert on that but I think getting girls involved in the sciences at a younger age helps. When I went to school, we didn't get exposure to science until we got into junior high. I was lucky because I was in an advanced program, the infamous Science Nine. I was blessed. I started seventh grade with physics and biology and chemistry, where a lot of students don't start until sometime in high school.

That's so true, we need to get more girls into the STEM programs. Just for fun, what's your favorite thing to do on a Friday night?

Wow. It depends. I like a really good meal with a nice bottle of wine and good conversation. I've got a friend and he and I normally meet on Friday nights. We get together and talk about our week and see where things are in life. We're of similar age and marital status, both single. He's very straight, I'm gay and we are very good friends. It's nice to share time with someone you can relate to who enjoys similar things. It's kind of like a surrogate relationship once a week.

How important are having women friends in your life?

It's very important for me to have both men and women friends. On a woman's perspective, I believe having female friends is a priority. There's the commonality of the experience of being a woman. We understand one another since we've been through similar things, like some of the physical and hormonal changes that are going on now. Most of my friends are my age or slightly older. I think that has to do with education level and the ability to relate to certain things. I tend to gravitate towards people who act like a mentor to me. I think that's why I trend towards the older, more educated population. Most of them are female from that perspective.

What advice can you share with young women about gaining power and opportunity with equal access?

Have a strong sense of self mindfulness. You've got to know who you are and what it is you want. You can't be erratic and scattered. You've got to know if you are going to go after something and have the heart to go forth and get it. Even if there's rejection, you've got to want it bad enough to keep going. Fall down, get up. You've got to have people in your support system that are going to help you maintain strength to overcome obstacles and succeed. You need good people you can bounce things off and make sure you're making good decisions. The mentor, mentee relationship is so important and very valuable to every woman out there trying to succeed. Thank you for the interview today, I have really enjoyed my time with you and discussing these issues.

It's not the size of the package that matters,
it's how many times you can deliver in one day.

Down and Flirty

Most women have a good sense about sexuality in the workplace, but some aren't aware that flirting or dressing sexy at work can have negative consequences. Successful and powerful women have learned how to embrace their own sexuality and know how to navigate the extreme of engaging in overly sexy or flirtatious behavior. Not using one's sexuality to manipulate others in the workplace is a critical component for gaining power and influence.

POWER TIP

Overly sexy or flirtatious behavior can be hazardous to one's career.

Abby, an aviation worker shared that she worked with a colleague who was on top of her game. Word had it she was slated to move up to a senior leadership position, that of vice-president of the company. "I was intrigued with how she chose to respond to men at work. Co-workers often gossiped that while she was a dynamo associate, it often came with a wink, a slight nudge of her body on their shoulder, and just plain flirtatious behavior with everyone. I was not surprised when she was passed over for the job by a man with half her qualifications."

Men are attentive to every move a woman makes. How a woman crosses her legs is probably the most noticed behavior and one that sends mixed signals. In the compelling book *The SeXX Factor*, the authors share a perception from one of the males interviewed. "I feel somewhat threatened because she has all the control. All the props that men use, the traditional big desk, the big chair, all those things are there to impose authority and control of a situation. Now an attractive woman walks in to do business and crosses her legs… who's in control now? Or she thinks she's in control."

Another male executive from the book summarized his feelings about women's sexy attire at work. "The only thing that bugs me is when women intentionally blur the lines of the roles and then get pissed off when we get confused. Like if a woman wore a see-through blouse and then got mad when her subordinates were distracted or started flirting with her."

Men love to flirt and are drawn to attractive women. It's a power thing for them. Don't try to hide your sexuality, rather be aware that flirtatious gestures show a lack of power. When you take a seat in front of him, make points with your ideas rather than your feminine attributes to get what you want.

Excerpted from Ryder & Briles. The SeXX Factor: Breaking the Unwritten Codes that Sabotage Personal and Professional Lives (New Horizon Press, 2003).

Daddy's Girl

Have you ever been treated like a "little girl" by a man who has power over you? If so, you are one of many women who have experienced a lack of respect from men in the workplace. For men, respect is a given, but for women in the corporate world respect is difficult to get.

POWER TIP

Don't treat me like a little girl! I want to be treated as men's equal.

When a man walks into the room, people are convinced he knows what he's doing, but for a woman, she needs to prove herself to gain that respect. And the same thing happens when men treat women like children at work.

"This patriarchal attitude that women need protecting or can't do something on their own is killing

me," shared Kelli, a senior advisor for a large oil corporation. "I can't stand it. I get patted on the head; I overhear them referring to me as *the girl in the back office*. I call these guys out which tends to make things even worse. My recommendation to other women is speak up when this happens and if it doesn't stop seek out the help of a trusted boss or supervisor."

Women place a central role in men's lives as mothers, daughters and wives and will do everything in their power to protect them. [19] We get it, but many men see no contradiction in protecting the women in their lives while at the same time treating their female colleagues with these same protective behaviors.

"It's just off-putting," said Sally, a skilled carpenter. "These guys treat me like I am just one of their kids. I do the same amount of work as the men and I can lift and climb ladders just like them. I want to be treated as their equal."

Guilty as Charged

Do you ever feel guilty taking a call from work at home with your family? How about the choice to meet friends over attending your child's soccer game? Or that call to your mom you forgot to make? If any of these scenarios resonate, know that you are not alone. Most women experience feelings of guilt at least four times a day. And as women we tend to experience higher levels of guilt than men. So, what's the answer?

POWER TIP

Guilt is a bitch. Don't let it own you.

Knowing how to deal with guilt can help. There are two types of guilt, healthy and unhealthy. The healthy guilt is relatively easy to understand in it helps to improve relationships and behaviors such as making amends

when you've wronged someone or apologizing when you've made a mistake. Unhealthy guilt, on the other hand, is more difficult to overcome and can hinder a women's confidence.

For example, women often feel guilty for things that are beyond their control. Danielle, a director for a consulting firm said she always feels guilty when her boss wants people to work longer hours and puts down those who don't comply by saying they are not team players. "These subtle innuendos that if we don't work the longer hours than we are not part of the team are humiliating. I feel like I am being manipulated when this happens. I need to learn to stand up for myself."

Alexa, on the other hand, talks about managing the guilt she feels over things she cannot control. "I have come to the realization there are some things I just can't control, like having to be in court for a big case when my kid is having her science fair. I want to be there for her, but if I miss the court date, we all lose. Recognizing that there are some things I have no control over eases my discomfort. I try not to be so hard on myself and explain this rationally to my child. She's a smart girl and I think she understands. I want her to grow up and not experience guilt like I have."

Mistakes are the worst offenders for guilt trips. Some women can't let go of a mistake. Tami, an account executive shared that she keeps asking herself over and over what she could have done differently to prevent her sister from falling. "I should have told her the steps were steep. I should have told her to use the handrail. I just can't let it go. I feel so guilty about her being laid up and missing work."

Should a, would a, could a. Be mindful of guilt trips from others and your own self-imposed. It may be difficult but try to let go of guilty emotions that can erode your confidence.

While boarding Birdlie Airlines #723 to Hawaii, Phyllis and Frank panicked as they were greeted by their two female pilots. "Looks like we picked the wrong week to quit drinking," thought Frank.

Katy O'Dare

Age 55
Professor, Community College

Katy was a high school dropout destined for failure. Through hard work, perseverance and determination, she rejected the narrative and went from GED to her Doctorate. Her passion for education began with a twenty-year career in the Navy, where her focus was on the education and training of her sailors. Katy is the perfect image of a woman most of us would love to be on a good day. She speaks her mind, tells the truth and doesn't give a "damn" about what people think about her. Back to reality, she is composed, calculated and focused on doing the right thing to acquire influence in her career and community. This woman has a story that few could share. And we loved it!

Thank you for being with me today on this wonderful Sunday morning. I'd like to begin this conversation talking about confidence. What do you believe has contributed to your self-confidence?

When you walk into a space as a woman of color you must have confidence and that takes years and years of focus and practice. It takes time. At times I suffer from imposter syndrome which means that I must take a lot of time for myself to prepare. I find that I must reflect on how far I've come and know that I'm worthy to be there. It takes confidence when you walk into a room and you're the only person that looks like you. That is not an easy thing. That takes a lot of practice.

That's interesting. Can you share something you have accomplished recently?

A couple of things that I've done this year that's been kind of cool was that I took a temporary job as an administrator at my college. It didn't really work out that well. After I stepped down from the position, I went back into the faculty ranks which gave me more time to think. Because the job was so toxic, I took a year to refocus and reorganize. Another accomplishment was something personal. I am a golfer and I love to golf. I was in a club championship and I was doing well. At the end of our two-day tournament we were tied. We had to have a playoff. When I went to tee up my ball, I was so nervous that my hand was shaking. Well, I didn't play my best and lost by two strokes. Losing that championship has been on my soul for a whole year. I realized that I was not mentally prepared, and I knew I could have done better.

What impact did losing that championship have on you?

How many people like to lose? Not me! I spent the year focusing on being more mentally prepared.

Another major accomplishment just happened, and it wasn't something that was on my radar. I had a meeting with a neighbor who's been on the local school board. I should have known when she invited me to coffee what she wanted. She approached me about running for the school board and I said I don't know that much about the K-12 school systems. All I know is that I was a high school dropout.

She said, "We need your leadership." Then she told me about the woman I'd be running against who was a "ban the books" type of person. That didn't sit right with me, so I decided to register and run against the woman. After registering as a candidate, I found out the woman dropped out of the race and even resigned from the position.

But there was still some unfinished business with that club championship. It was sitting on my soul. Everything I've done this year has been to refocus and reorganize so that I'm the best possible version of

myself. I'm now on the school board, and I even won that club championship by nine strokes. I was on fire! And not only that but I was asked to be on an advisory committee for an administrators of color mentorship program. This year I've been very laser focused in self-care and being very intentional with my time and energy. I'm going into this school board position, really jazzed up. I'm excited.

I'm happy you won the championship. You talked about suffering from the imposter syndrome. Can you share an example?

It's horrible having that imposter syndrome because you question yourself. So how do I deal with that? I think it's about staying engaged and staying focused. I was asked to be the keynote speaker at an alternative high school this past June. The reason why I do these speaking engagements, especially to high school students is because I was a high school dropout. I attended the event dressed in my full regalia and the first thing I said to them is that I wasn't supposed to be here. The narrative was already written for me. I shared my story about being a high school dropout and that I was told I wasn't going to amount to anything. For me, I feel like I am giving back and lifting people up by telling my story. Which always helps to pull me out of that imposter syndrome.

That's amazing. You went from having no high school diploma to a doctorate in organizational leadership.

I have always loved something that Shirley Chisholm once said. "When someone doesn't want to offer you a seat at the table then you bring your own folding chair." That's been my mentality because I refuse to be ignored. The other thing is because I teach at a community college, I require my students to call me Dr. O'Dare. I need for them to see me for what I am. When I tell my students my story, it makes an impression on them. I don't want them to think that I'm better than them, so I share the stories to help them stay engaged. It's very important for my personal and professional development.

In thinking about personal appearance, is looking good a high priority for you?

You're not going to catch me going anywhere without 'being on point' as I call it. Perception is everything. If people don't know you, you can't just walk in with sweatpants and a t-shirt to a meeting. When I go out, I make sure everything looks good on me so there's not something a person can pick apart. We all know there are people out there that are going to look at you and pick you apart, so I just take that off the table.

That's interesting. I love your concept of taking things off the table.

Absolutely. You must. It's all about taking things off the table as a woman and especially as a woman of color. For me, it was getting my bachelor's degree. Well that's off the table. Get your Master's degree. That's off the table. Excuse me, you don't have your doctorate? Well guess what? That's off the table. The more you take off the table the better so other people don't judge you. Of course, it depends what you want out of life.

I feel the same, but doesn't it get a little tedious after a while?

I have this weird ritual when I have something important, I do a lot of what I call 'pep talk'. I pep myself up and get myself ready when I need to do my best work. I say, Okay you're good enough. You're smart enough. I always practice my speech. I don't want people to judge me. So yes, it gets tedious but it's a ritual for me. I know that successful people have rituals that work for them.

What's the harshest criticism you ever received?

The hardest criticism I've ever received was when I participated in a 360-degree activity in which I asked the people who work for me and those that I report to, to assess my leadership. The results were anonymous. As I was reading them someone said I wasn't a good communicator and another said I wasn't good on diversity. I hired all these people and they gave me some feedback that was tough to hear.

What did you do as a result of that criticism?

I took it and ran with it. I dove in to become a better communicator and more open and inclusive in my decision making. I took the results seriously and asked people what they needed from me regarding communication. I put together a group and we all came together to talk about this. I invited everybody to the table, and they shared that they needed a voice. So, I stepped back and let them talk. It was nice.

Yes, feedback is so important. What's the best advice you've ever received?

The best advice was around communication. I was advised to go out and talk to people. I had to go out and listen to the people who hated the work I was doing. One guy who was angry at me was the most difficult. At first, I thought he was just some bitter old guy and I didn't know what to tell him. I asked him why he was so angry. I took some notes and then realized that some of the things he was complaining about were things that we could address. I went back to the president of the college and said these are what people are saying and here is what we can do about it.

What did you take from your experience in the Navy to make you who you are today?

I was in the Navy for 20 years and had a nontraditional job for a woman where I worked on a flight deck. When they signed the combat excursion law in 1994 allowing women to serve in combat roles, I had my choice of ships, and I picked an aircraft carrier, the USS Lincoln, and got orders there. As soon as I arrived, I outranked every female within my department. I had males who were ranked lower than me who were rude, disrespectful and challenged my authority. They wouldn't pay attention, wouldn't follow my orders. It was a big problem because I couldn't go to my supervisors and tell them my people wouldn't follow me, it was a tough assignment and place to be, but I worked it out. Eventually they came to respect me. After 20 years in the

Navy, maybe the one thing I learned is you must come in like a bad ass. You come in like Annie Oakley. You want people to see you as someone who knows what you're talking about, and don't ever let anyone rattle your nerves because people are going to push you. People are going to test you. I learned to trust my instincts. I still have that bond with some of those people today, they are my brothers and sisters. It took time to build that camaraderie. You don't get that outside of the military, but when you do get it, it's awesome. I learned to be Annie Oakley. You can't take shit from anybody. The people who allow themselves to take shit will never be successful in the military. They always end up getting out. That was very significant for me.

I had no idea it was that difficult for women first entering combat zones. Your Annie Oakley metaphor is a good one. On another subject, are you married or in a relationship?

I'm married to a woman for 21 years.

Congratulations. That's a long time! I didn't know you were gay?

Yes, I don't put it out there because as always there are people that judge again. I try to keep my Facebook professional. You remember I came up in the military in the 80s when being gay was illegal. Remember my whole theory is that I take things off the table, right? I don't need people judging me on that. Okay? I don't share about myself until you get to know me. I use this thing called the Johari window which is about keeping certain things close until someone gets to know me. Then I open my window a little bit and I allow you to come in and get to know me more.

That is great advice. What do you think is the key to a happy marriage?

I think in a happy marriage you must have a good sense of humor. Never take anything personal. When you fight, fight fair. If you have a disagreement, don't give up. My parents were together, forever, 57 years. You just don't give up. I mean, it's unbelievable, people just give up and

say, "I'm done." Really? You're done? You don't want to try to work it out until you know more about why you are not wanting to stay together? Then if all else fails abort the mission. If you're in it and if your heart is in it, then you know you've got to work at it. It isn't easy. It's just like with anything. The same thing applies to work.

How's that?

I know a lot of people move around jobs and say their organization's horrible or the people are bad and want to leave right away. For example, my organization right now is a five-star hotel with bedbugs and it's really a bad situation. I took some advice from my former president on his way out the door and he said, "Stay above the fray." So, I'm keeping my butt above the fray while the chaos is going on. I'm going to get more professional development. I'm going to better myself professionally rather than trying to bale.

You've talked a lot about courage throughout your story and the thread that continues is that you have tremendous grit. Could you talk about a time in your life when you had grit to take on something you didn't think you could do?

My gosh, I was so upset about losing that golf tournament. That stuck with me for a long time. Overall the most courage took going from a high school drop-out to where I am today. I realize it's the same thing with everything I do. You walk in and you don't think you can do it. Then you pull yourself up from whatever and get it done.

I want to talk a little bit about personal power, an interesting concept for females. How do you present your personal power when you're at work?

You do more. I get my personal power by not sitting around on my butt and doing nothing. I was asked by a student to be the advisor for the brand-new black student union. Boom I'm in there. I was asked by a local Congressman to start a person of color group. I'm there. I try to be a mentor to students of color and to faculty. I'm out there for my

veteran students. Last year I received the Faculty of the Year Award. I was nominated by a veteran student. When you ask about personal power, I think it's all about showing up and saying "yes" to things we are offered or asked to be a part of.

That's excellent. I just went to a conference this weekend and a woman talked about that very thing. You take it on if you can. Do you have any advice for women about gaining confidence?

Get a mentor. That's the most important advice. Then after getting a mentor ask yourself what it is you want to be. Do you want to be president of the United States, do you want to be president of a Fortune 500 company or president of a college? You begin with the end in mind. Then once you have answered that question for yourself you identify these people and examine their resume. Research who they know, what organizations they belong to and what degrees they have. Then work your way toward that. Remember, you want to take things off the table. For example, in my case, you can't really be a Dean at a college unless you have a doctorate.

How did you find a mentor?

They are everywhere. Personally, I would go to conferences and professional development opportunities and find people who could mentor me. They will always say 'yes' and hold you accountable. I went to a conference and was desperately looking for a mentor. I ran into this woman and told her I was looking for a mentor because I was struggling. She was glad to help.

A lot of research on women suggests they suffer from a lack of confidence. Why do you think that is?

When do people ever talk about gaining confidence? I mean, no one teaches confidence, we just expect that you're going to learn it on your own. It's like riding a bike. You're going to fall off. The more things you

try out in life and the more you fail, the more confidence you get. A mentor will help you with that.

You make a good point. You're a gay woman, you're a woman of color and you're female. You have three perceived barriers in front of you. What are your secrets to being so confident?

Yes, and don't forget that I am a disabled vet. I keep believing that you have got to work hard and take things off the table. When you go to work don't talk about the barriers. Talk about work. You don't go in there and talk about your problems. I came up in the Navy, before 'don't ask, don't tell' and so I always had a mentality that it's your personal business. I always get offended when people ask a woman if she is married. Then they always follow with, do you have kids? Oh, you don't have kids? Oh, you didn't want any kids. What? Why are you asking me? I'm here to work. It's very insulting. People will find out you are married and then will want to know where your husband works. I always tell them she worked for the government and she's an engineer in tech.

Yes, I am beginning to understand.

It wasn't an issue when I was in the military because you had such a diverse workforce. But coming out in civilian life there is not that much diversity. A lot of times I would be the only person of color. There's been a transformation that had to happen with myself. I had to say when you work your whole adult life in the military, you must relearn things to understand diversity, equality and inclusion. I am somebody coming in a little late to the game. You feel alienated when you walk into a meeting and you're the only person of color. You go, okay, here we go. I knew exactly what I needed to do. I got involved in a social justice leadership Institute.

I really enjoyed talking with you. Do you have any parting words for women on how they can be as successful and happy as you?

Here's the thing. My advice is don't treat other women like we are the enemy. People are going to try to divide us and come between us. I believe it's so important to get away from the work situation and break bread with one another. I think having a meal with someone changes the dynamic in the narrative. You know, we're allies, we're in this together. No one knows and understands more about the struggles and the trials and tribulations of being a woman better than us. We must depend on one another and be able to say, I need to talk to my sister over here. Thank you for interviewing me today. This has been enlightening and fun to talk about my journey.

"Today's seminar is on 'The Future of Women's Equality'. Would one of you men in the back with the ear buds run out and get us some Kombucha and snacks?"

FINAL EXAM

As you read each question, circle the answer that best reflects how you would react in the following situations. If the question scenario does not apply to you (i.e. parent, getting married), stretch your imagination and think about how you would respond if you were in that situation since after reading this book you should be an expert!

1. You haven't been feeling well for the past two weekends and have had to cancel plans with your friends.

 a. You worry they will start to include you less and less because of your absence.

 b. You know that your health is more important and trust your friends will understand.

 c. You go anyway and hope you feel better.

2. You've been trying to lose 20 pounds and your coworker tells you that your new body looks great. You say,

 a. It's been really hard losing the weight but I appreciate the compliment.

 b. I'll never get to my ideal weight; dieting is hell.

 c. I've always been a big woman but I think losing this weight is important.

3. You are out to lunch with a new acquaintance. Instead of placing the bill in the middle of the table your waitress hands your acquaintance the bill.

 a. You offer to split the tab but they insist on paying. You thank them kindly.

 b. You offer to split the tab but they insist on paying. You accept but feel guilty and beholden to that person.

c. You get out your iPhone and begin to calculate the cost of exactly what you ate and had to drink. You hand them $30 and ask for $5 back.

4. Your female boss is a true pioneer as she is one of the few females to make it to the top. She is however, too hard on you and often makes you look bad in public.

a. You read up on the concept of Female Queen Bees and decide your best strategy is to keep out of her way.

b. You ask other females in the office if she treats them the same way.

c. You schedule a meeting with your boss to discuss how some of her comments are making you feel small and figure you have nothing to lose.

5. Your child's traveling soccer team has unexpectedly made the regionals and will be going overnight Friday through Sunday. They must have a parent in attendance. You are the parent but have committed to finalizing a work project that weekend with your team.

a. You inform your child that your job is critical to the family's financial well-being and tell them they cannot attend the regionals and that you will make it up to them.

b. You ask your best friend to chaperone the event.

c. You decide to attend the tournament and feel secure your position and contribution to the project will be recognized.

6. You are managing a team of 30 people, two of which are female. You begin to see one of the female team member's wardrobe is a bit too revealing.

a. You address the situation and handle it on your own privately with the employee.

 b. You send the employee to the HR department to go over the dress code and recommend she be put on warning.

 c. You point her out to one of your team members and ask if they can talk to her about proper work attire in the office.

7. You are the one in charge of paying all the monthly bills. Your roommates/partner are consistently late to transfer their share of the payments to your bank account.

 a. You let it go and anxiously wait until they come through with their payment.

 b. You call a casual evening meeting and offer suggestions on how to collect your bill payments in a timely manner.

 c. You approach your roommates/partner in a loud and stern voice demanding payment on a timely manner or they will be penalized a fee.

8. You have roommates you love and adore. However, recently they have been bringing their friends back to party into all hours of the night. Consequently, you're not able to sleep well and feel energized for the next day.

 a. You storm out of your room and ask them to quiet down.

 b. You lie in bed tossing and turning. As a result, you are sleep deprived and suffer the entire next day.

 c. You ask everyone to meet up after work the next day to come up with a list of house rules that will satisfy everyone.

9. You witness your co-worker taking advantage of the company's resources above and beyond what is entitled to any employee.

 a. You ignore the situation but wish you were as brave as them.

 b. You immediately consult with your supervisor about the situation.

 c. You pull your co-worker aside and advise them they should be careful and that you would hate to see them suffer any consequences if found out.

10. You feel overwhelmed at work and know you need to take a day off to collect your thoughts and engage in some self-reflection.

 a. You power through it knowing that by missing a day of work, things will only get worse.

 b. You fear taking the day off, since your boss is ready to give one of your projects away to a coworker.

 c. You take the day off, collect yourself, catch up on some personal work and feel rejuvenated.

11. When dropping off your children to school late, the Vice Principal greets you and adds a comment, "Finally, your children aren't the last ones to arrive!"

 a. You pull over to the curb, get out of your car and let them know just exactly how much you try to be a good, single parent.

 b. You roll down your window and thank them for welcoming your child to school while wishing them a pleasant day.

 c. You get out of your car, approach the Vice Principal and remind them who pays their salary and how much time you have volunteered at your child's school.

12. Your hairdresser has been styling your hair for twelve years. For some reason she has really missed the mark with your haircuts lately.

 a. You let it go and don't bring it to her attention for fear of offending her and the repercussions of hair appointments to come.

 b. You let her know how much you've appreciated her service all these years but that she needs to pay attention to your haircut at that moment and make sure it is her best effort.

 c. You share your concerns with how she's been cutting your hair and have a conversation about how she can satisfy your needs.

13. Your closest circle of friends is planning a vacation which is above and beyond your budget.

 a. You don't want to feel left out so you charge all of it to your credit card.

 b. You call members of your immediate family asking to borrow money.

 c. You let your friends know it's just not in the budget now and wish them a good time.

14. You are out with a friend from work but unfortunately, they have had too much to drink. You insist on an Uber but your friend wants to drive you home.

 a. You ask them to get a cup of coffee and talk for a while.

 b. You let them know they are in no shape to drive. You ask if you can call one of their friends to help get them home.

 c. You ask for their keys, lock the car and both share an Uber home.

15. Wow what a perfect match for you and your new date via .com. You are really head over heels for this person. However, you are so embarrassed by the way they dress.

 a. You say goodbye and hope they get a fashion consultant.

 b. You secretly take a few pics of the fashion plate to show your friends while seeking advice if it's worth a second date.

 c. You go with the flow, ignore the bad taste and try to enjoy the evening.

16. The company holiday party has arrived and everyone who is anyone in your organization is in attendance. The co-worker that has been the thorn in your side and trying to show you up has too much to drink. Their behavior is way too promiscuous at the party.

 a. Even though you aren't fond of her you feel sorry and escort her from the party without a scene hoping people will see you help another woman in need.
 b. You point out her behavior to the people you are surrounded by and have a few laughs.
 c. You approach her closest friend at the party and ask her to escort this person inconspicuously from the party.

17. It's exciting when you find out you are pregnant. You let your supervisors and the HR department know of your news.

 a. You live day to day anxious whether you will be accepted back to the same terms and position when you left.
 b. You understand the maternity benefits your company offers. You have no anxiety about your leave of absence and feel confident your position will be there when you return.
 c. You dwell on the hearsay and rumors floating around the office about what happened to other women on maternity leave.

18. You are offered a chance to present your project at a large dinner reception to over 500 people. Many of those in attendance will have the power to promote you in the future. You believe your presentation skills are not up to par.

 a. You work on a PowerPoint with your friend, practice it regularly until you feel confident you can do well.
 b. You are honest with yourself and know that you will mess up. You tell your boss that you'd like to pass on this opportunity but to keep you in mind for future presentations.

 c. You approach your colleague who is good at this type of large-scale presentation and ask him if he will present with you.

19. You are in your golf club's club championship and know if you take the next hole you will be the champion. Your competitor is your dear friend. Your friend has hit her ball just on the edge of the woods. You see her move debris that causes her ball to move. This would incur a penalty stroke. She should call it on her own but doesn't. If you call her on this infraction you are sure to win.

 a. You don't want to win this way so you overlook the incident and play on.

 b. You believe in honesty is the best policy so you acknowledge the ball moved and you bring it to her attention.

 c. You let her know you saw the ball move but having to play one of your best friends is hard. You let her know you are not going to call her on it and play on without her incurring a penalty. She is grateful and thrilled that she may still have a chance to win.

20. You have sold your home and the closing date is set for the 1st of the month. The buyer needs to push it out two weeks with an unexpected vacation he must take with his family. You will now have to pay additional costs for storage and shipping your belongings.

 a. You insist on the original closing date and deal with the consequences.

 b. You advise your realtor that you will accommodate them but it will mean any expenses you incur with the delay will be at the buyer's expense.

 c. You are fearful of ruffling any feathers and agree to whatever the buyer wants at your expense.

21. You have a medical appointment and find out your procedure or exam will be performed by a male.

 a. You are uncomfortable with a male assigned to you but will have the procedure done anyway because you just don't have the time to come back.
 b. You are so taken aback and let the receptionist know that under no circumstance will you ever have a male physician examine you. You reschedule your appointment.
 c. You are told a female practitioner is available a half hour later. You kindly accept to wait and have your appointment.

22. All the women and their spouses around you are having children. You and your husband do not want to have a family. You can't avoid those family questions but they always occur.

 a. You pretend and tease your friends and tell them 'maybe someday'.
 b. You are so tired of people asking you that you finally put an end to the matter and let them know it is no one's business.
 c. You are frank with your friends and let them know the two of you do not want to have a family and you are very happy with your decision.

23. There are so many charity events you are asked to participate and contribute to financially. You need to step up to your best friend's cause.

 a. You don't have the money to contribute so you honestly let them know.
 b. You ask if there are any other ways you could contribute to their cause other than financially.
 c. You let them know that you will definitely contribute with a donation but hope they won't find out you have no intention of supporting their cause.

24. You are out one evening and happen to see another friend with someone other than their partner.

 a. The next morning you plan to meet your friend for brunch and let them know what you saw.
 b. You confide in some of your friends about what you saw but avoid telling the person it will hurt most.
 c. You keep it to yourself and wait for your friend to find out on their own.

25. You hear rumors that the parents of some players on your daughter's varsity lacrosse team are paying for private lessons on the weekend from the girls' varsity coach. These players are starting every game while your child is on the bench and very qualified to play.

 a. You back off and let it go into a very long season of pay or play.
 b. You report this rumor to the athletic director and request he investigate the matter.
 c. Having no truth to these rumors you continue to badmouth the coach to all the player's parents hoping they will get aboard your bandwagon and do something about this problem.

26. You really want to apply for the new position at work with more authority, prestige and salary. You are hesitant to throw your hat in the ring because you're missing a few of the required skills.

 a. You decide it's best to wait until you are fully qualified for the position.
 b. You work on your resume, work with a professional consultant and go for it!
 c. You don't apply because you know the company already has a man in mind for the job.

27. You've been dating this person for six months but are not sure if you want to get any further involved. However, there are many perks while in this relationship. You enjoy being treated to lavish dinners, expensive vacations, concerts, shows, sporting events and parties with their very popular circle of friends.

 a. You just can't pretend this relationship is going anywhere. You are honest, break up with them and give up all the goodies.
 b. Summer is just around the corner and you know there will be fun in the sun every weekend with this person. You go along for the ride hoping you will eventually get that butterfly, heart pounding feeling.
 c. You tell them you just want to be friends and see if you can still coattail on a few "sun"sational weekends.

28. You are hosting the family holiday party for 35 people and learn two days prior that your partner has invited her brother who you have not seen in 12 years. Her brother never accepted your same sex relationship but for some reason wants to be in your lives this holiday.

 a. You keep harmony with your partner and set another place setting.
 b. You just can't understand why someone who has no place in their heart for the two of you wants to open it up on the biggest holiday of the year. You ask your partner if their brother could come and visit another time.
 c. You love your partner and don't want to cause any friction at the party. However, you do not want to see this person. You make plans to visit friends for the day.

29. This past year you were told how hard you'd been working and the positive results your department acquired. Going into your annual review you confidently expected to receive a glorious review with a significant financial increase or promotion. You're blindsided and learn they perceived you as performing average in all facets of your job.

 a. You want to justify why you believe you deserve more recognition but instead you are silent, take what they give you and accept their evaluation for fear of jeopardizing your future with the company.

 b. You don't accept their evaluation. You ask your supervisor to document specifics of where you did not perform or meet expected goals. You request another meeting with your supervisors to better understand how they perceive you in your role with this company.

 c. You are totally taken off guard and become emotional and overwhelmed with how to stand up for yourself. They offer you a Kleenex and escort you out of the office.

30. Your company has access to a very popular co-ed gym. You are excited to join and get yourself in shape. You are looking a bit middle aged but you need to be healthy. You aren't comfortable around men but this gym is affordable and you don't have any other choice.

 a. You ask your teenage daughter to lend you some appropriate exercise gear to wear in the gym and sign up for tomorrow's spin class.

 b. You ask other women in your office to join you after work for one of the weekly yoga classes and then a light dinner at the gym's healthy food bar.

c. You take a look at yourself in the mirror and decide there is no way you will reveal yourself to the opposite gender in spandex. You open a fresh bag of chips, watch "Ray Donovan" and decide to get into shape in your living room.

31. You've been with your company for eight years and are well respected as a hardworking and devoted employee. You are informed the Sr. VP of Marketing is visiting your sight and you are going to be showing them around the plant and offices. Your supervisor informs you that all you need to do is show up on time, wear a pretty outfit and look attractive while these people visit.

 a. You are so busy with client requests and problems on your sight that you don't have time to process what this man just said so you let it go and move on.
 b. You are revolted by his comment and ask to speak with him privately about how uncomfortable he made you feel regarding your worth with the company.
 c. You document the moment by immediately confirming if there are any witnesses to his remarks. You confirm the time of the harassment for any camera or video found to have been recorded within the area. You write everything you can remember about what he said down on paper. You excuse yourself and report directly to HR to file a harassment claim.

32. You've noticed your male co-worker has become less and less personable with you while at work. You are told by your manager you are both being considered for the regional team manager in your area. This is a huge opportunity becoming one of only three female regional managers in the company. Your co-worker, was brought in from a competitor less than ten months ago.

 a. You initiate a meeting with your immediate supervisors to present your case on why you should become the regional team manager.

 b. You get bitter and turn on your co-worker by talking badly about him throughout the company.

 c. You update your resume and begin to look into the possibility of changing jobs and moving to a new company.

33. It's time to go "back to school shopping" for your three children ages 9 through 14. Your kids have given you the items they need to have in order to be cool and popular. Being a single parent is challenging especially when you need to say "No" to your kids. This back to school trip will cost close to $1,000 when it's over and done.

 a. You tell your kids you love them more than a pair of sneakers and settle for the imitations found in Walmart.

 b. You buy everything on their lists and wake up with buyer's remorse.

 c. You review their list of back to school items and try to come up with a reasonable compromise. You also go over the family budget so they understand the value of money and the time and effort it takes to earn it.

34. You and nine friends are out to dinner. You all request separate checks. When you receive your credit card statement you notice on that date you were charged $535.00 by that restaurant. You don't keep receipts so you have no proof other than your word that you should have only been charged for your meal of approximately $50.00.

 a. You panic, become emotional knowing you can't afford this to happen right now. You call your parents for help.

b. You email and text your nine friends explaining the situation. You evenly split the cost of the dinner into 10 payments of $53.50 and ask them to kindly send you their share of the bill to your Vemo or Paypal account by the end of the week.

c. You start a text chain with the nine friends and request them to pay you their share of the bill even though you know this will turn into a never-ending nightmare trying to collect all their payments.

35. You are very successful in your career and with your company. You volunteer and contribute a great deal of your personal time while sitting on several committees related with your career, family and community. Lately you are feeling overwhelmed and would like to eliminate some of these responsibilities.

a. You don't want to let anyone down and before you know it six months have flown by. You are still at the same level of involvement and twice as overwhelmed.

b. You make a list of all of your extra commitments and decide which ones are of value to you and which ones are not. You draft a letter of resignation to those you decide to eliminate and mail them the next day.

c. You start to become MIA from several of your commitments without offering an explanation.

ANSWER KEY

1. b	2. a	3. a	4. c	5. c	6. a	7. b
8. c	9. b	10 c	11. b	12. c	13. c	14. c
15. c	16. c	17. b	18. a	19. b	20. b	21. c
22. c	23. b	24. a	25. b	26. b	27. a	28. b
29. b	30. b	31. b	32. a	33. c	34. b	35. b

SCORING

The maximum score you can have is 35, which would mean you are truly a confident, courageous and powerful woman and ready to take on the world.

30-35	Extremely Empowered	You should be called Superwoman as you are an extremely confident and powerful woman and have learned how to manage yourself to become a key influencer in your personal, work and community life. Bravo!
24-29	Frequently Empowered	You have a great deal of personal confidence and power and just need a little bit of fine tuning to take you over the top. Chart out a few areas of focus to work on and you will be on your way. Well done!

18-23	So-So Empowered	You are average in your courage and ability to showcase personal power which yields a so-so in return for what you do. Stretch yourself to do something different and begin to work on 5 or 6 strategies presented in this book. Select a woman in one of the interviews that reminds you of someone you'd like to be and look for areas you can emulate in your personal life. Nice work!
17 and Below	Not So Empowered	Your confidence, courage and power are shaky. It's time to do something different. Ask yourself two important questions. (1) Am I happy with how my life/career is progressing? and (2) How can I get more self-confidence to get things for myself? Select one or two strategies from this book to work on and don't stop there. You are aware that you need to change. Keep working on areas you can conquer and continue to seek out more mentors, self-help books or podcasts to take you to the next level of confidence. Good luck! We care!

FINAL IMPRESSIONS

Twenty years ago as a school principal, I asked a good friend if she thought I had what it takes to become a school superintendent. She looked at me and said, "Maybe." I was crushed. What's this maybe?

Then she laid it out on the table. You have a wonderful personality, are smart, and have the drive and ambition, but I'm not sure you will make it to the top of your field.

"Why not?" I cried?

You need to work on your confidence, get a new hairstyle, and monitor your speech and how you are perceived by others. You are a great friend and a very successful school principal, but I just can't see you leading a school district the way you are now.

I decided to seek a second opinion. Same story. The next day I went to the library and took out some books on Executive Presence in the workplace and building self-confidence. After taking a few self-assessments I learned that I needed to hone in on my communication skills, act assertive and dress more professionally in the workplace. I also began to take small steps to increase my self-confidence.

And guess what? It worked. By taking hold of a few actions and working on them over a few years I could feel myself changing and acting more confident. People started treating me differently. They began to listen to me and show respect as if they thought I had influence and power. Four years later, I received a job promotion to a superintendent position. I was their first woman superintendent!

The bottom line: You can also make a change in your life. The areas addressed throughout Don't Forget Your Lipstick, Girl and recommendations we've made via the Power Tips are designed to help you gain more confidence and power in your work, personal, social, family and home lives. The information given and ideas and tips suggested are

based on years of experience investigating women's issues, combined with the latest research, some of it our own, some of it based on that of others.

What can you do now after reading this book? Start by reassessing your performance on the Final Exam. By now you should better understand some areas that impact your ability to gain confidence and exhibit courage throughout your life. Take time to go back over some of the Power Tips relevant to your life and experiences and review them.

By developing your own awareness in areas that are contributory agents of undermining your self-confidence, you will strengthen your resilience to offset the damaging effects on your career and access to everyday power.

Select three to five focus areas that you personally believe you can work on to improve your confidence and place in the world. Use the following table to focus your target areas.

Target Areas

Five focus areas or behaviors that I intend to target include:

1. _____

2. _____

3. _____

4. _____

5. _____

To get the most from the concepts we have discussed you not only need to reflect on the workings of your own personality and behavior styles but you also need to consult with critical friends to verify that the changes you make in your life are having the desired results. Like me, you may have to get a second opinion. Also don't forget to seek out personal and professional mentors to guide you along the way.

In conclusion, it was an honor to interview the women in this book who shared their secrets for how they manage to succeed in a complicated, goal driven society. Each interview was a pure gift, soaking in their stories of confidence, courage and personal power. On the back side they shared their experience with the Imposter Syndrome, attempts to find strong mentors, and feeling marginalized when learning they were paid less than their male equals. Most books for women showcase people that have made it to the top. We chose to dive deep to interview confident and successful women who are still growing and eager to share their life's strategies. They are not famous nor are they fully able to find that sweet spot in the world that they know exists. But they have goals, and the confidence to actualize their dreams. They are awesome, strong women, sisters to sisters, sharing a few hours of their time to tell their story.

Please take time to access our Sister to Sister Website to become part of our community and learn more on how to change the conversation for all women.

https://www.sistertosistersecrets.com/

MEET THE AUTHORS

We want this book to be about you, our readers, but you may want to continue reading our compelling story about growing up when times were different for women. This link will take you to the full version: https:// www.sistertosistersecrets.com/the-way-we-were

The Way We Were: Marilou, 1960

As a ten-year old girl, I wanted nothing more than to become a player on the local Little League team. Playing baseball with my male classmates after school provided me with athletic confidence, and I rarely missed hitting the ball out of our small neighborhood stadium. My batting average was better than most and I was becoming a local hero among the little league crowd. My father, president of the Optimist Club, sponsored several Little League teams in town. I recall asking him if I could join one of his teams. He was the father of five daughters and a huge proponent of sports, so I thought he would take the request seriously. He responded by claiming there were "no girls" allowed on these teams. I was disappointed, but little did I know that a ten-year old girl had no chance of playing on a Little League team in 1960. Hoping to change his mind, I went into the bathroom and cut my hair to look like a boy. ***It didn't work.***

The Way We Were: Jessica, 1964

I loved being a kid. I was an outdoor kid who loved playing in our barn, running with our cats and dogs, helping my dad with the chores and playing with the kids in the neighborhood. I always felt I could keep up with the boys athletically and academically and I attribute my early athleticism to my dad. Had it not been for his military service during WWII, he probably would have been a professional athlete. He loved sports. And he loved his girls. Though he never had a son he still managed to slip a few footballs, trucks, hockey sticks, golf clubs, skis, banana bikes and baseball gloves under the Christmas tree each year. He taught me how to be competitive by encouraging my participation in sports. I recall my father working hours to build and groom an ice rink in our front yard. Having access to a skating rink was my gateway to learning how to ice skate and competing in ice hockey games with the neighborhood kids. What girls played ice hockey in 1964? In grade school I was a bona fide Tomboy and proud to show off my confidence among my male peers. As a result, the boys wanted to hang around me, often asking for my help when building their tree houses. They knew I was athletic, smart and of course, knew that my dad had an unlimited supply of tools. I will always be grateful for the courage and confidence he instilled in me as a little girl. I sensed that he was clearly aware of the challenges I would face as a woman throughout my life.

NOTES

1. Kay, K., & Shipman, C. (2014) *The Confidence Gap*. Retrieved from https://www.theatlantic.com/magazine/archive/2014/05/the-confidence-gap/359815/

2. Hesse, A. (2017). The feminist history of red lipstick. Retrieved from https://yourdream.liveyourdream.org/2017/09/feminist-history-of-red-lipstick/

3. McKay Rosenberg, D. (2019). *How To Deal With Personal Issues At Work*. Retrieved from https://www.thebalancecareers.com/how-to-deal-with-personal-issues-at-work-526107

4. Marsh, S. (2016). *The Pressure Of Perfection*. Retrieved from https://www.theguardian.com/commentisfree/2016/oct/14/perfect-girls-five-women-stories-mental-health

5. Kim, J. (2016). *Why Women Can't Accept Compliments*. Retrieved from https://www.psychologytoday.com/us/blog/valley-girl-brain/201603/why-women-cant-accept-compliments

6. Salemi, V. (2010). *Start Smiling: It Pays To Be Happy At Work*. Retrieved from https://www.forbes.com/2010/08/13/happiest-occupations-workplace-productivity-how-to-get-a-promotion-morale-forbes-woman-careers-happiness.html#604e39aeefb4

7. Holeman, C. (2013) *Financial Advisors/Leaders Improve Delegation, Pass The Baton*. Retrieved from https://www.clientwise.com/blog/blog/bid/85591/financial-advisors-leaders-improve-team-delegation-pass-the-baton

8. Mayo Clinic. (2004). *Aerobic Exercise: Ten Top Reasons To Get Physical*. Retrieved from https://www.mayoclinic.org/healthy-lifestyle/fitness/in-depth/aerobic-exercise/art-20045541

9. Corkindale, G. (2018). *Overcoming The Imposter Syndrome*. Retrieved from https://hbr.org/2008/05/overcoming-imposter-syndrome

10. Lentz Triplett,E. (2019). *The Value Of Doing Things That Scare You.* Retrieved from https://www.helpscout.com/blog/do-things-that-scare-you/

11. Knutsen, A. (2018). *Women's Empowerment Through Education.* Retrieved from https://yourdream.liveyourdream. org/2018/06/womens-empowerment-education/

12. Sandberg, C. *Quotable Quotes.* (2018). Retrieved from https://www.goodreads.com/ quotes/792737-as-women-must-be-more-empowered-at-work-men-must

13. Canter, L. (2019). *Why Holding A Grudge Is Bad For Your Health.* Retrieved from https://www.webmd.com/anxiety-panic/ news/20190327/why-holding-a-grudge-is-bad-for-your-health

14. Amen blog. (2016. *The Number One Habit To Develop In Order To Feel More Positive.* Retrieved from https://www.amenclinics. com/blog/number-one-habit-develop-order-feel-positive/

15. Victor Blog. (2017). *The Power Of Serving Others.* Retrieved from https://blog.victor.org/the-power-of-serving-others

16. Bradberry, T. 13 *Habits Of Exceptionally Likable People.* Retrieved from http://www.talentsmart.com/articles/13-Habits-of-Exceptionally-Likeable-People-507024439-p-1.html

17. Filler, K. (2018). *The Importance Of Female Friendships Among Women.* Retrieved from https://www. psychologytoday.com/us/blog/happiness-is-state-mind/201808/ the-importance-female-friendships-among-women

18. Kleon, Austin. (2012) *Steal Like An Artist.* Workman Publishing Company, New York.

19. Hogg, R. (2016). *Power, Patriarchy And Men's Contradictory Attitudes To Women.* Retrieved from https:// www.theguardian.com/commentisfree/2016/aug/19/ power-patriarchy-and-mens-contradictory-attitudes-to-women

Made in the USA
Coppell, TX
16 May 2020